TREASURY OF ANIMAL ILLUSTRATIONS

From Eighteenth-Century Sources

EDITED BY

Carol Belanger Grafton

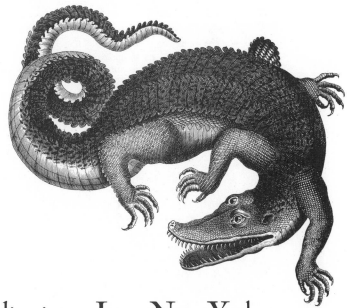

Dover Publications, Inc., New York

Treasury of Animal Illustrations: From Eighteenth-Century Sources is a new selection of plates from French natural-history publications. The original French engraved labeling has been deleted, and new English captions, publisher's note and index provided. See Publisher's Note for further details.

DOVER *Pictorial Archive* SERIES

Manufactured in the United States of America
Dover Publications, Inc., 31 East 2nd Street, Mineola, N.Y. 11501

Library of Congress Cataloging-in-Publication Data

Treasury of animal illustrations from eighteenth-century sources /
 edited by Carol Belanger Grafton.
 p. cm.—(Dover pictorial archive series)
 "A new selection of plates from French natural-history publications"—T.p. verso.
 Includes index.
 ISBN 0-486-25805-X (pbk.)
 1. Decoration and ornament—Animal forms—France. 2. Decoration and ornament—France—History—18th century. I. Grafton, Carol Belanger. II. Series.
NK1449.A1T7 1988
769'.432—dc19 88-22611
 CIP

PUBLISHER'S NOTE

Eighteenth-century natural-history illustration in France received tremendous impetus from the researches and writings of men like Buffon and Bonnaterre, who, together with colleagues (and then posthumous continuators), produced massive illustrated publications that were decades in the making, extending into the early nineteenth century. The numerous artists employed either in drawing the images or engraving the images onto copper plates for the printer, have left us an admirable legacy, of which the present volume offers a selection of outstanding examples. (At least some of the plates included here are from various volumes of Bonnaterre's *Tableau encyclopédique et méthodique des trois règnes de la nature*. It has not been possible to identify the source of all the plates or to name individual artists.)

Plates 1–23 illustrate mammals. (Whales, however, appear on Plates 76–78; this postponement is for technical reasons—to allow a double-page spread uninterrupted by the binding.) Birds follow on Plates 24–42. Reptiles occur on Plates 43–51 (snakes) and 55–60 (other reptiles), with amphibians claiming Plates 52–54. Plates 61–75 contain the bony fishes; Plates 79 and 80, rays and other fishes. Crustaceans, on Plates 81–95, are followed by arachnids on Plates 96–99, insects on Plates 100–105 and mollusks on Plates 106–124. Plates 125–138 present a token sampling of the superb botanical illustration of the same period; included are chiefly blossoms and fruits of tropical trees, some of which are of international importance as food plants.

All original French lettering has been deleted from the plates, and new English captions substituted. The identifications of the animals (or plants) in the captions (common English names only) ranges from the extremely general ("Crabs") to the extremely specific ("viviparous eelpout"). The possibilities of pinpointing species depended on the degree of recognizability of the images, the amount and quality of the identifications in the original French engraved labeling, and the degree of availability of reference resources. For most practical purposes, however, the extent of identification in the present volume should be sufficient. An index at the end of the book allows for speedy location of all identified animals (or plants).

The more than 600 classic illustrations included here, carefully reproduced in fine line from the original engravings, and easily reproducible from the book with no significant loss in quality, are a unique blend of artistic elegance and scientific accuracy (except for a tiny handful of extravagancies, which have a wayward charm of their own). They are certain to be of great use to artists, illustrators, designers, packagers and craftspeople in many fields, as well as to the many readers who enjoy leafing through fine illustrated works.

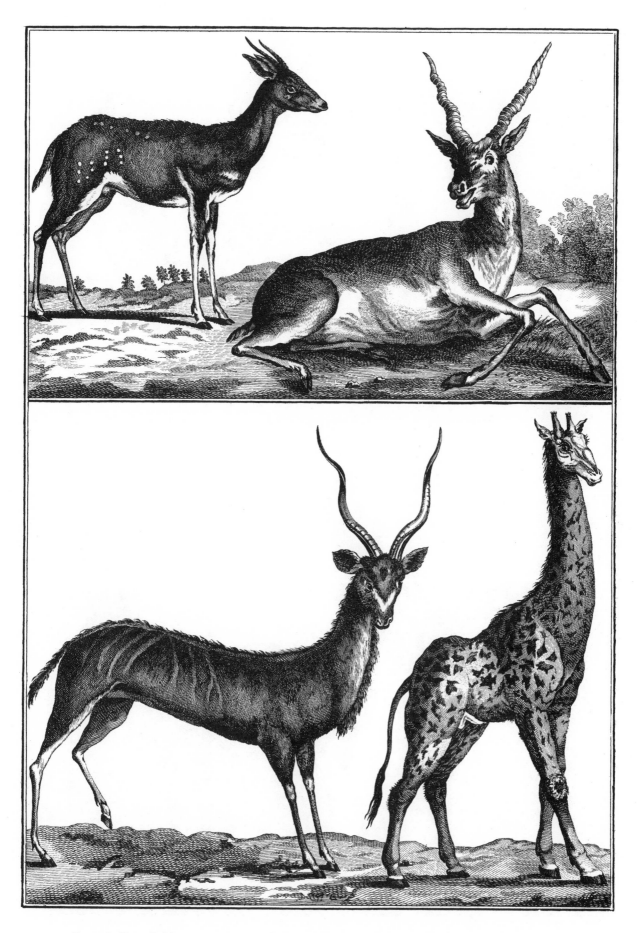

PLATE 1. Top: (left) sitatunga (or a related antelope), (right) blackbuck. Bottom: (left) lesser kudu (or a related antelope), (right) giraffe.

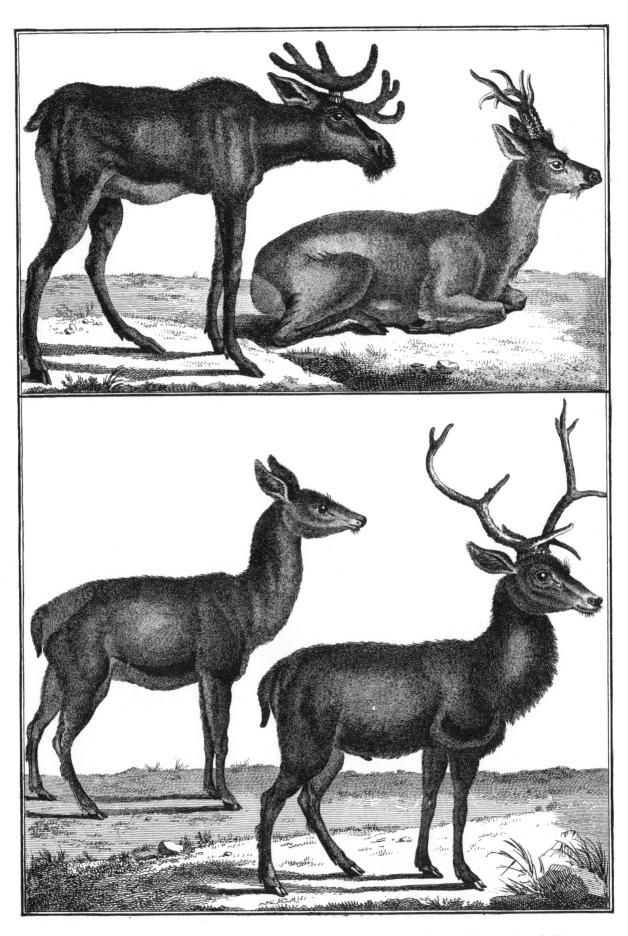

PLATE 2. Top: (left) elk (moose), (right) white-tailed deer (or a related deer). Bottom: doe (left) and stag (right) of the European red deer.

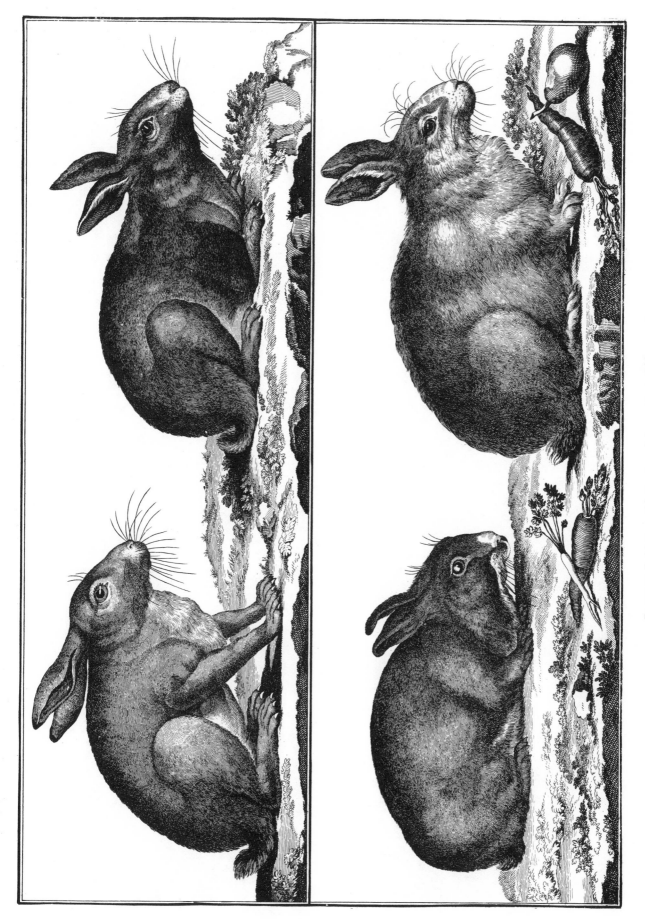

PLATE 3. Rabbits, wild (top) and domesticated (bottom).

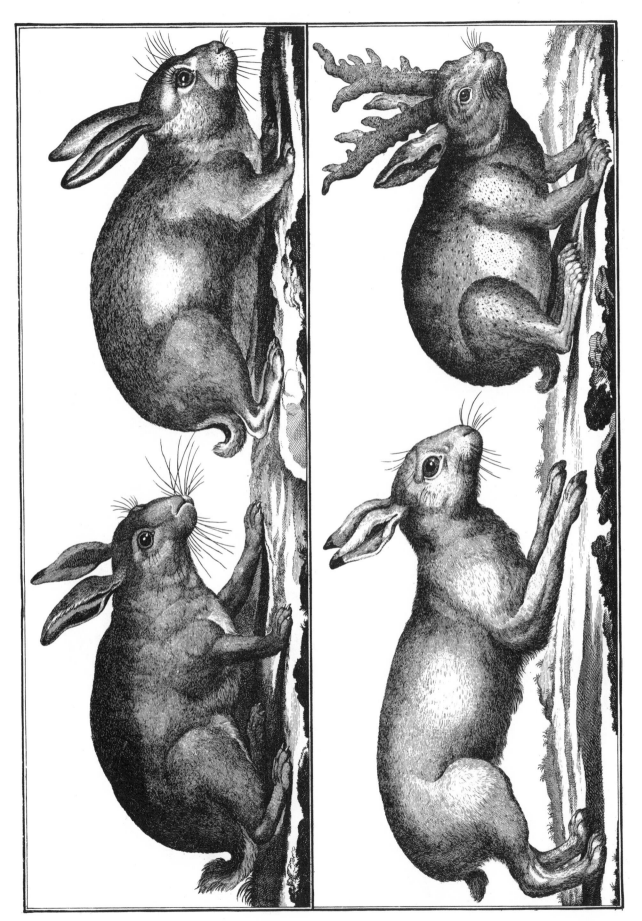

PLATE 4. Hares, including (bottom right) a nonexistent "horned hare."

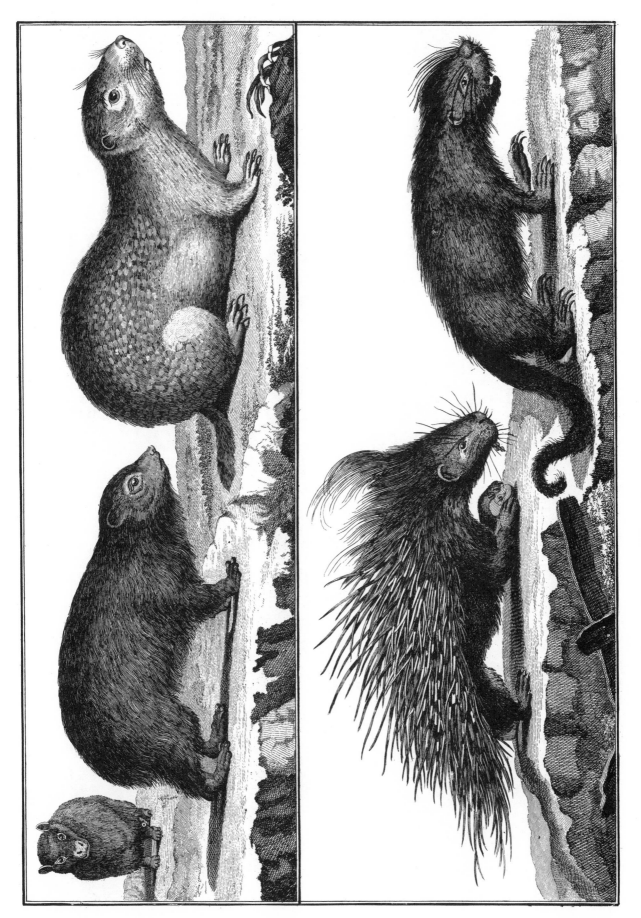

PLATE 5. Top: two species of hyrax. Bottom: two species of porcupine.

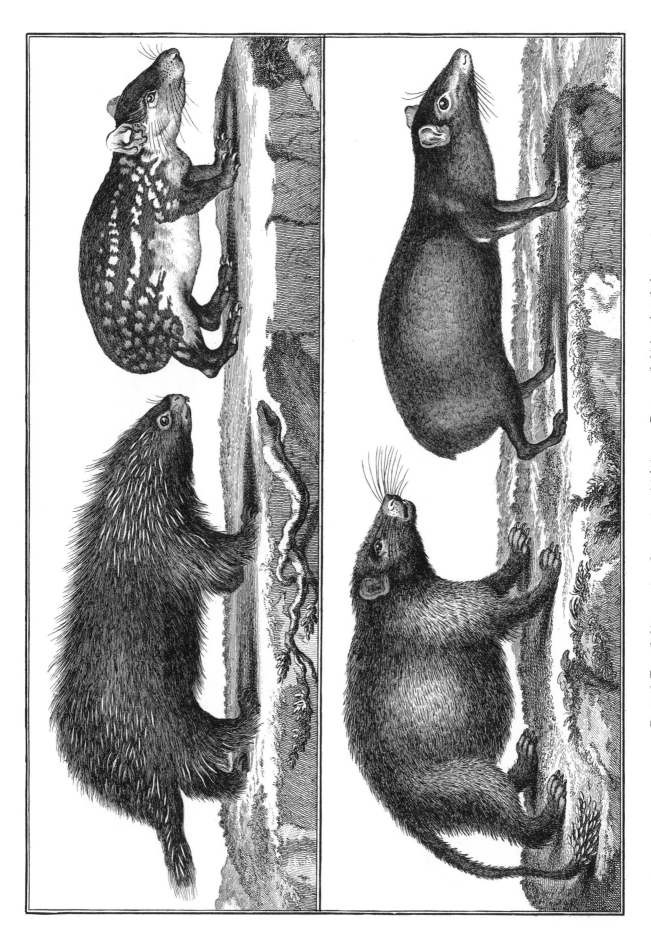

PLATE 6. Top: (left) a species of porcupine, (right) paca. Bottom: (left) brush-tailed porcupine, (right) acouchi.

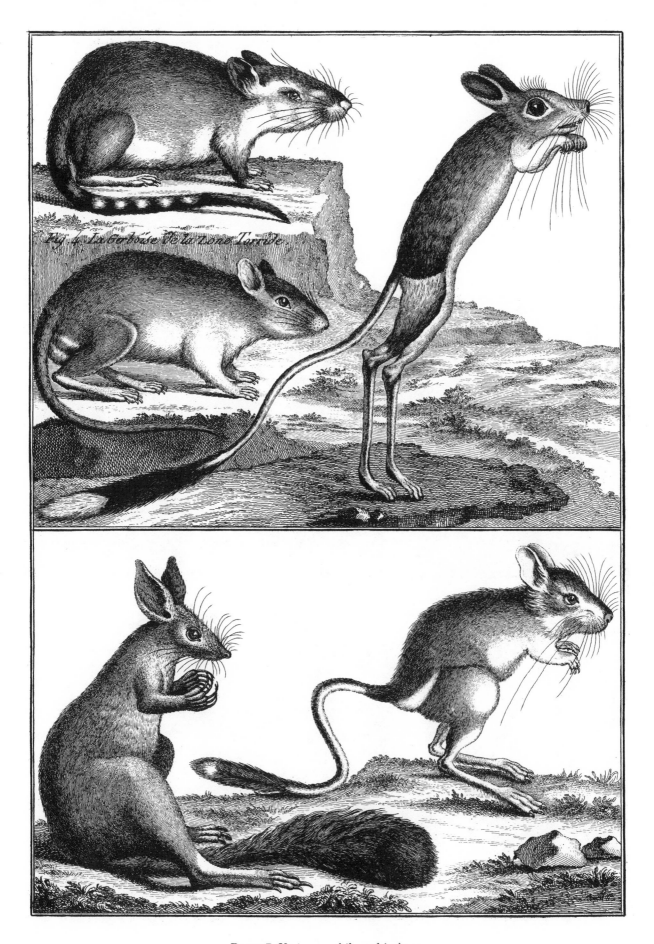

PLATE 7. Various gerbils and jerboas.

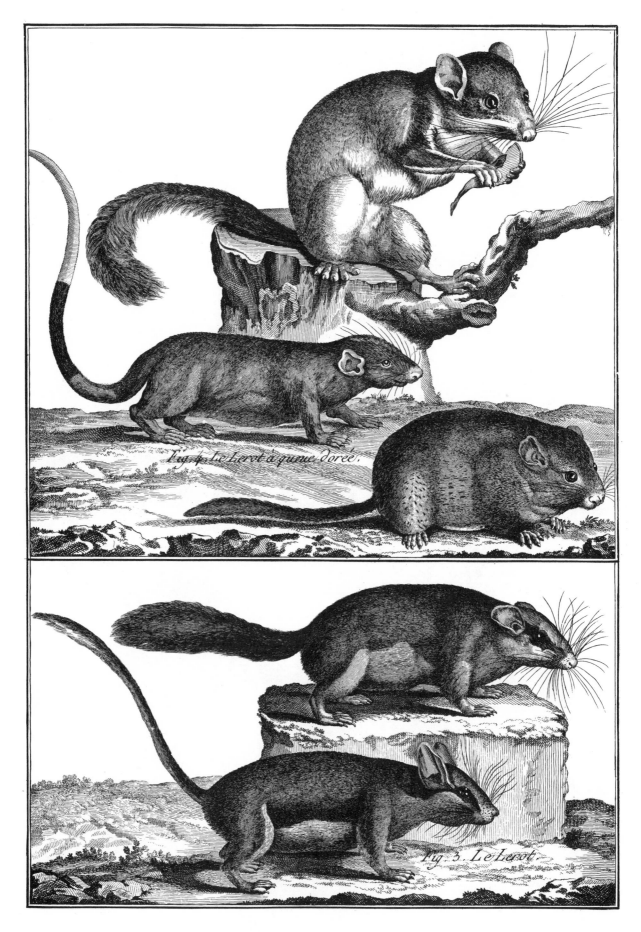

Fig. 4. Le Lerot à queue dorée.

Fig. 5. Le Lerot.

PLATE 8. Various species of dormouse.

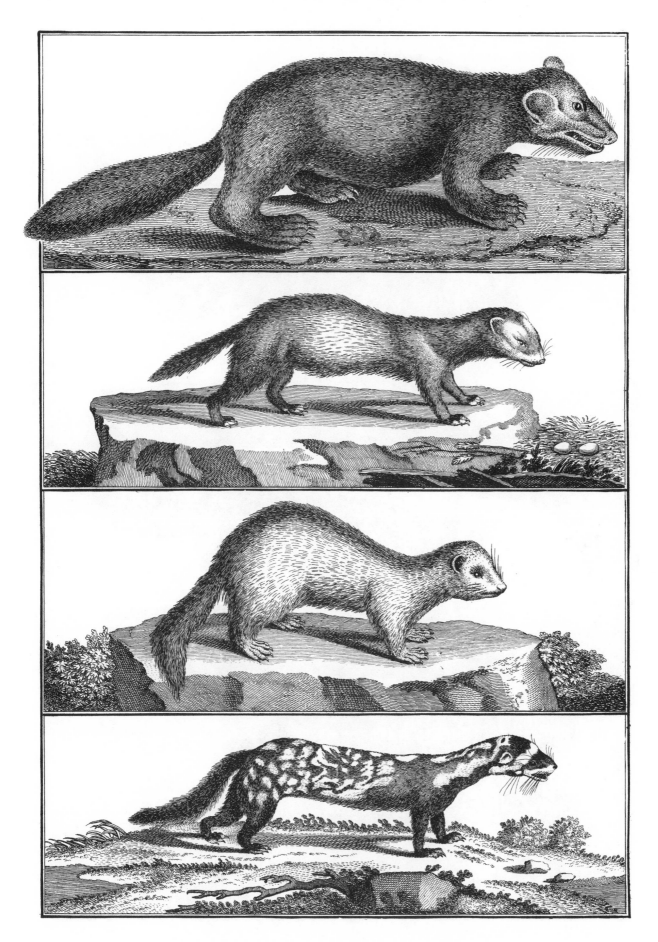

PLATE 9. Top to bottom: sable; polecat; ferret; marbled polecat.

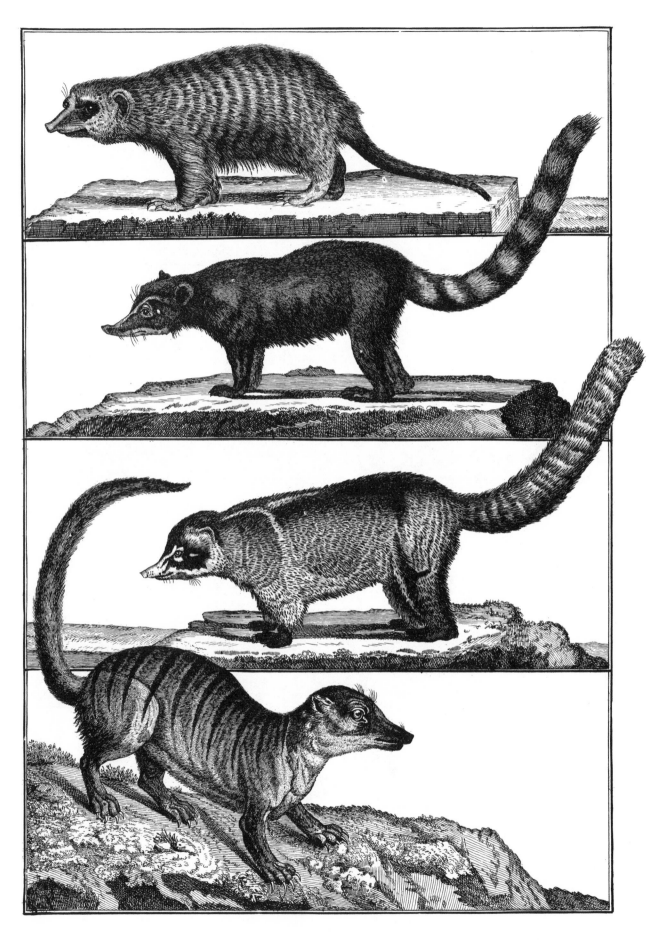

PLATE 10. Top to bottom: animal of the raccoon family; coatimundi; suricate; a species of civet.

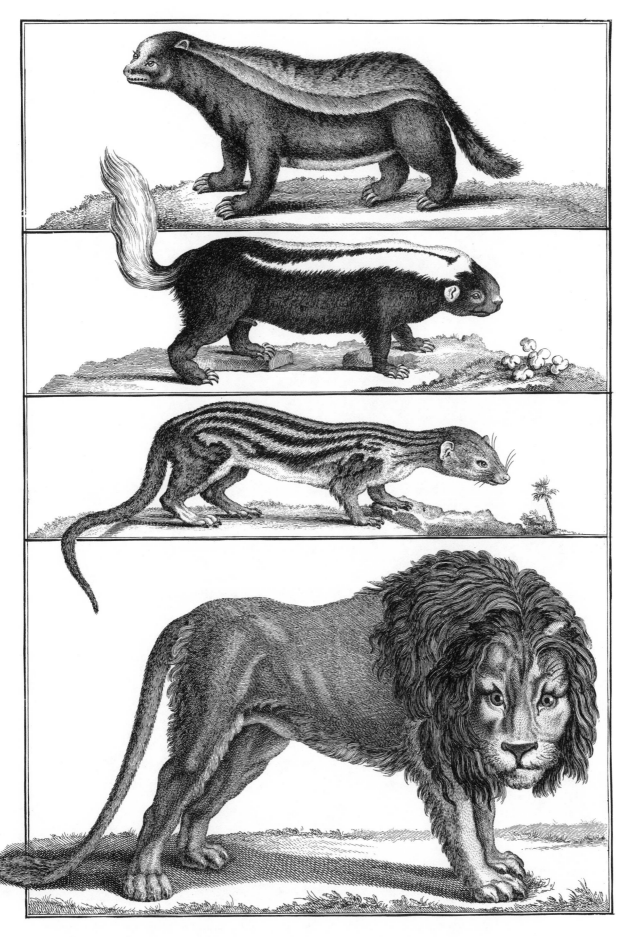

PLATE 11. Top to bottom: honey badger; Patagonian weasel; animal of the weasel family; lion.

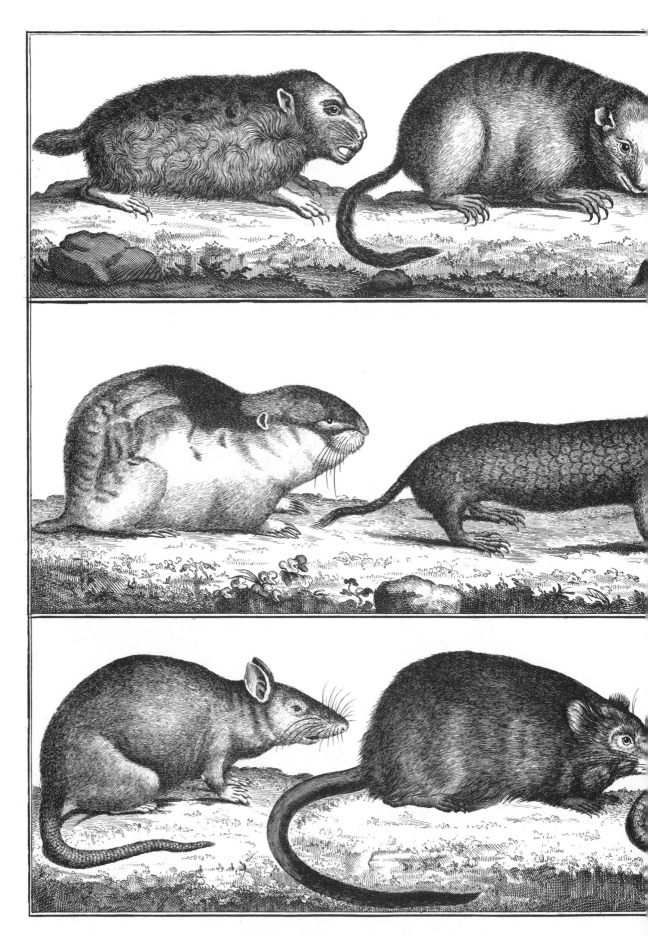

PLATE 12/13. Top: marmots and related rodents of the squirrel family. Center: lemmings; type of rodent; two species of rat. Bottom: Rodents (middle two are muskrat and wharf rat).

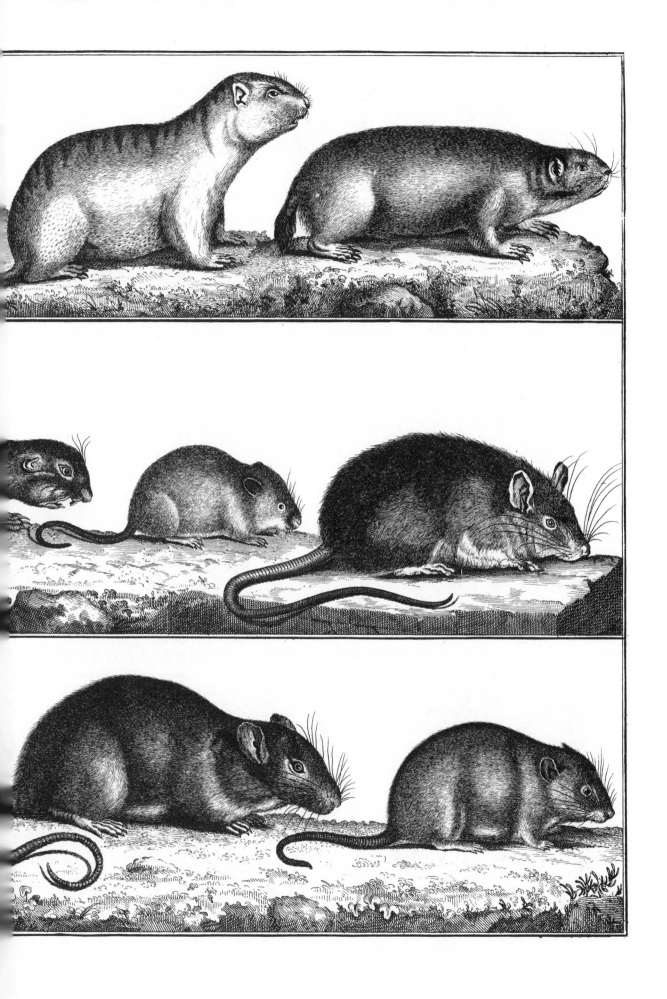

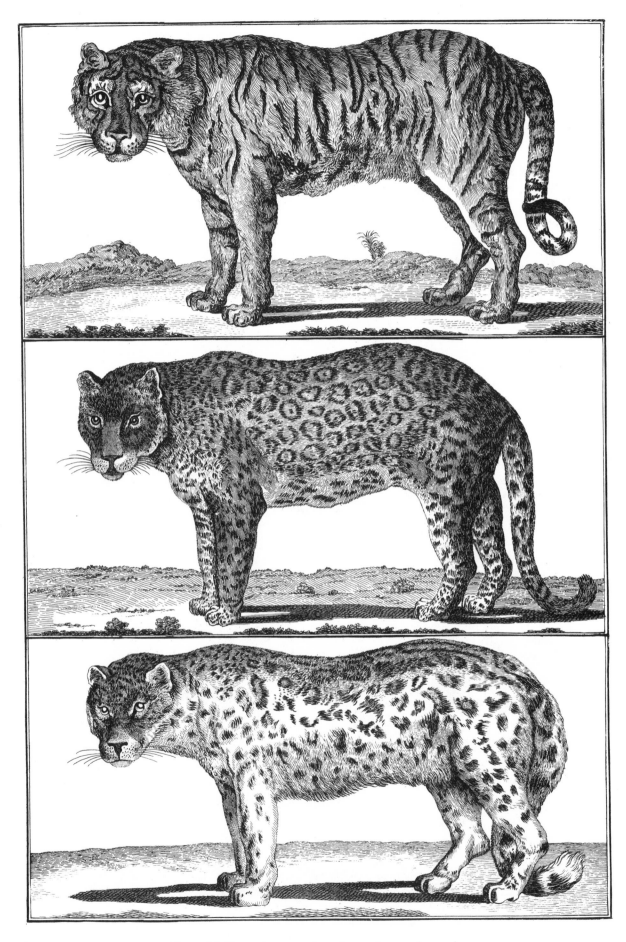

PLATE 14. Top to bottom: tiger; leopard; snow leopard.

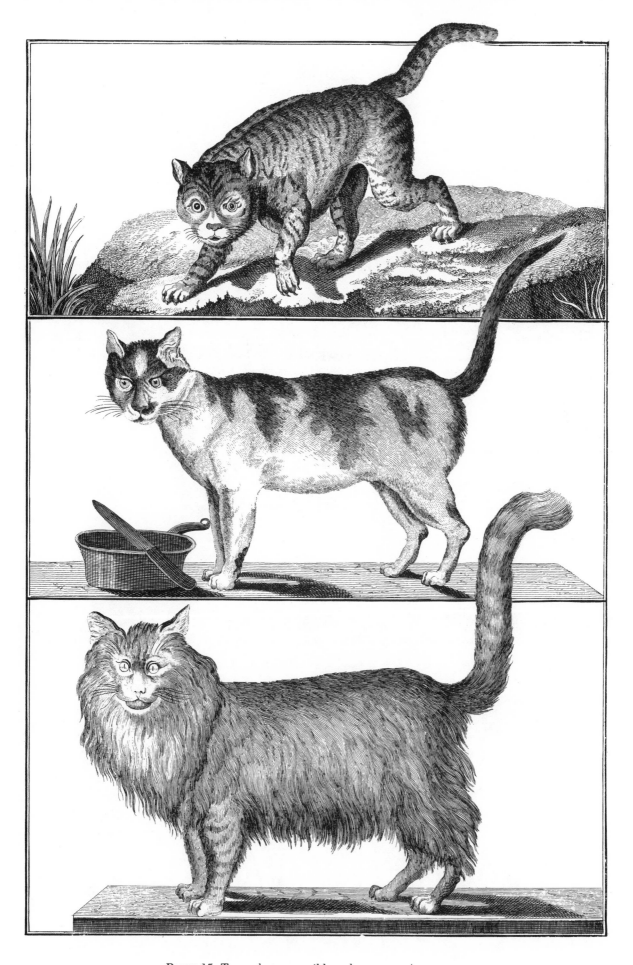

PLATE 15. Top to bottom: wildcat; house cat; Angora cat.

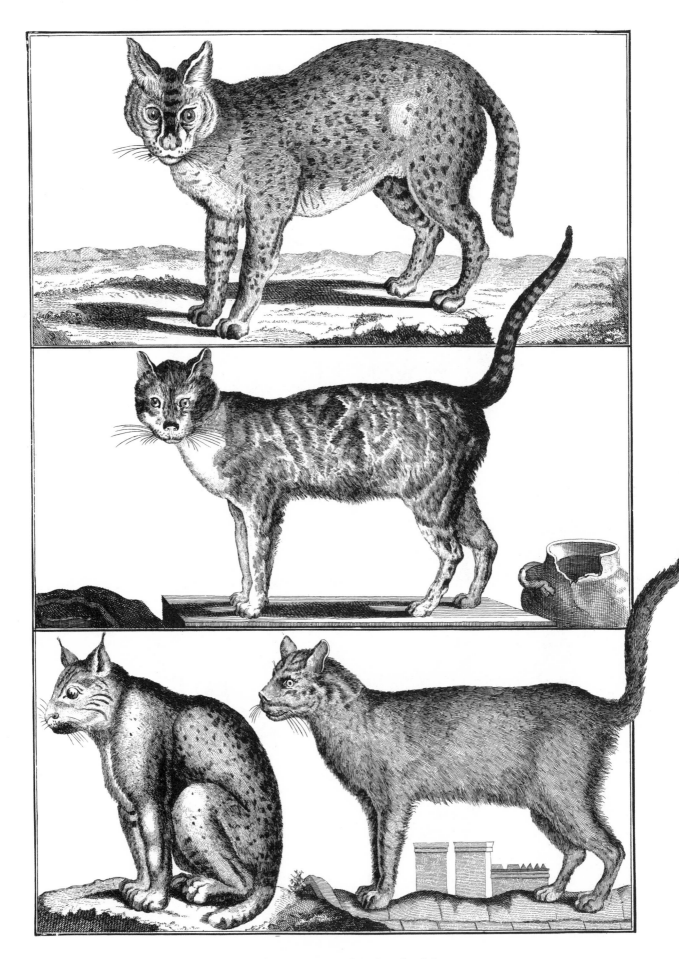

PLATE 16. Top to bottom: serval; three breeds of domestic cat.

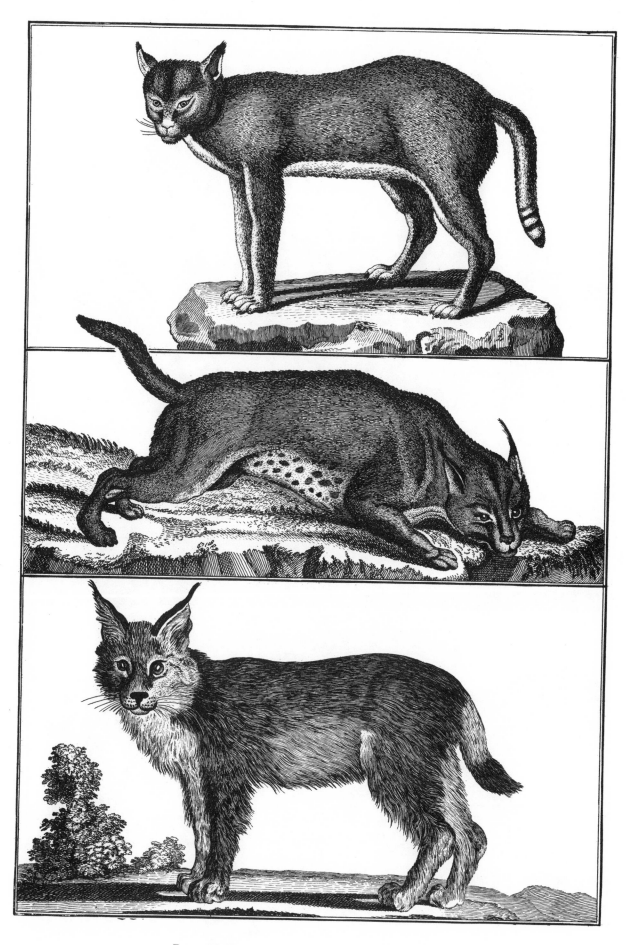

PLATE 17. Top to bottom: jungle cat; caracal; lynx.

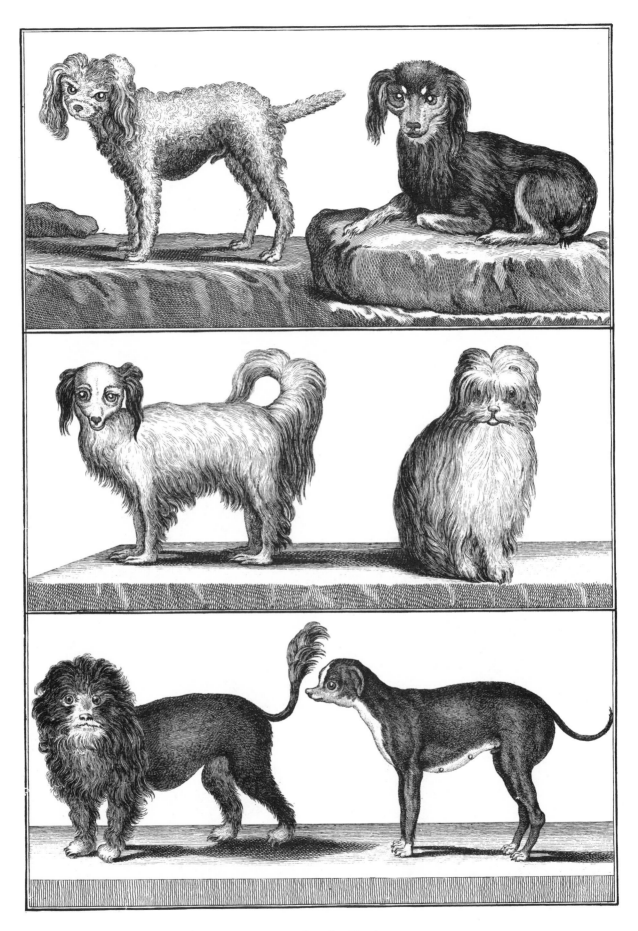

PLATE 18. Breeds of lapdog.

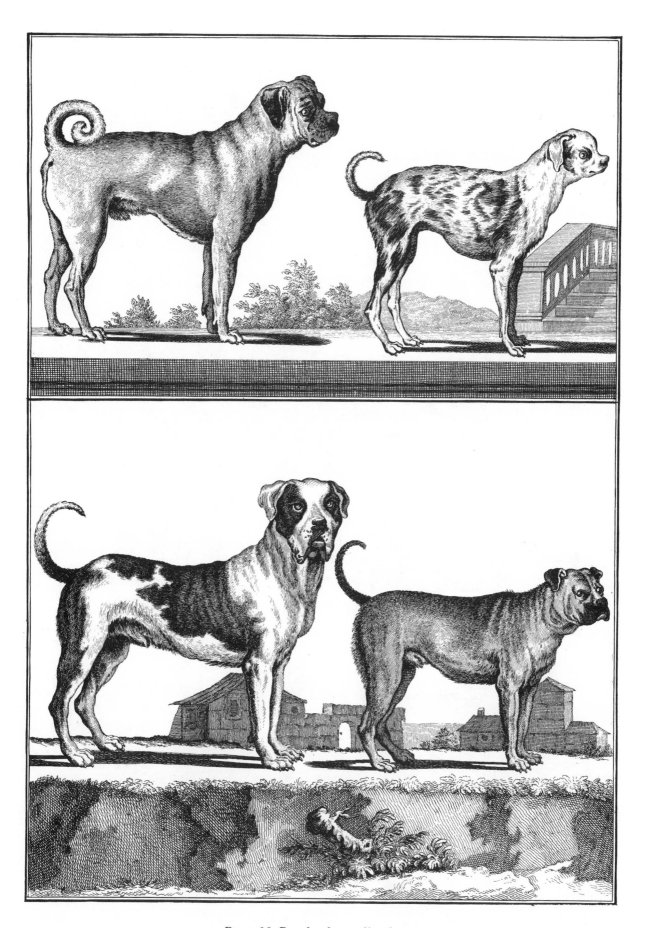

PLATE 19. Breeds of mastiff and pug.

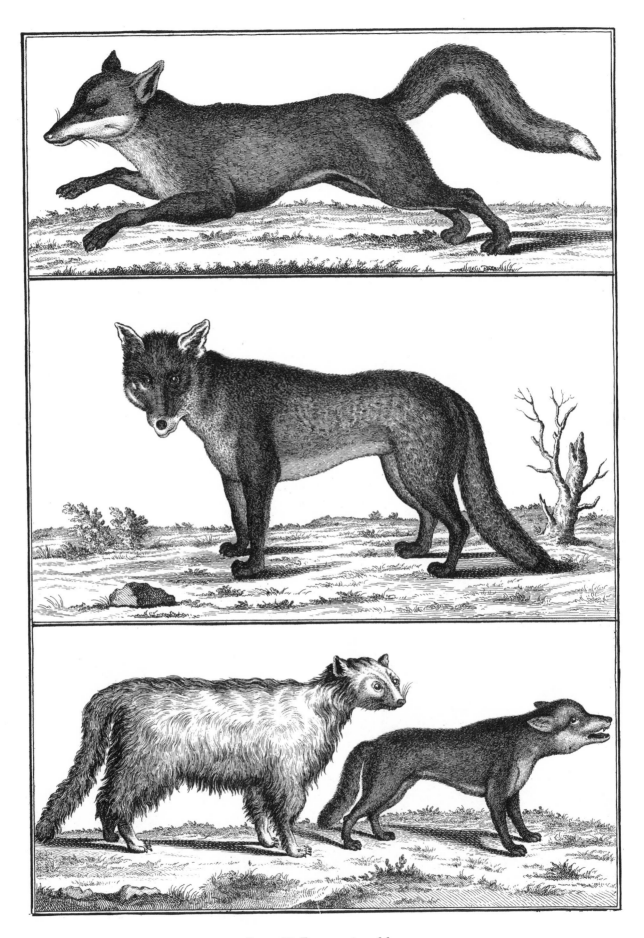

PLATE 20. Four species of fox.

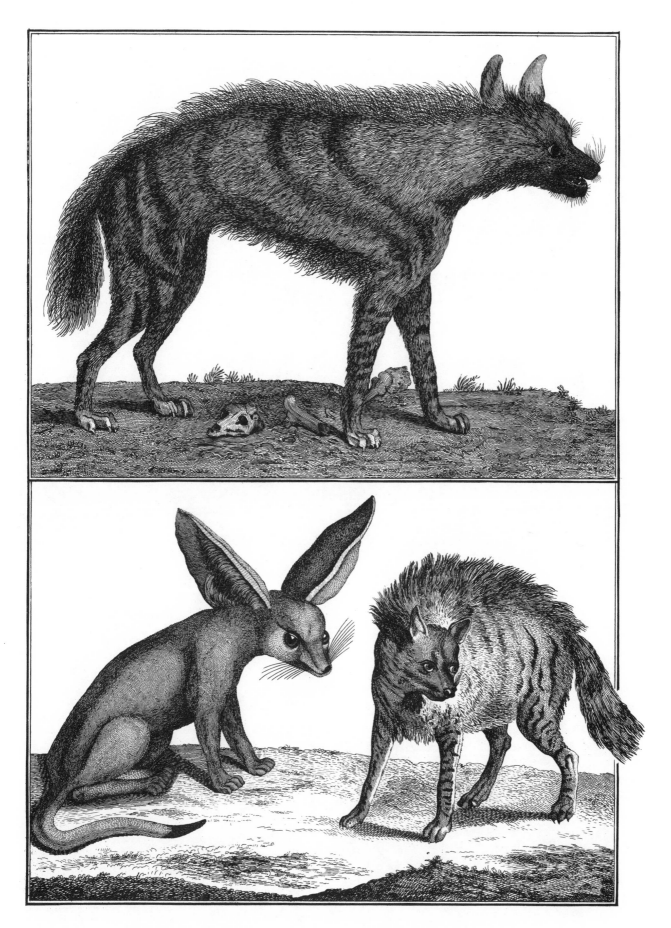

PLATE 21. Top: striped hyena. Bottom: (left) fennec, (right) brown hyena.

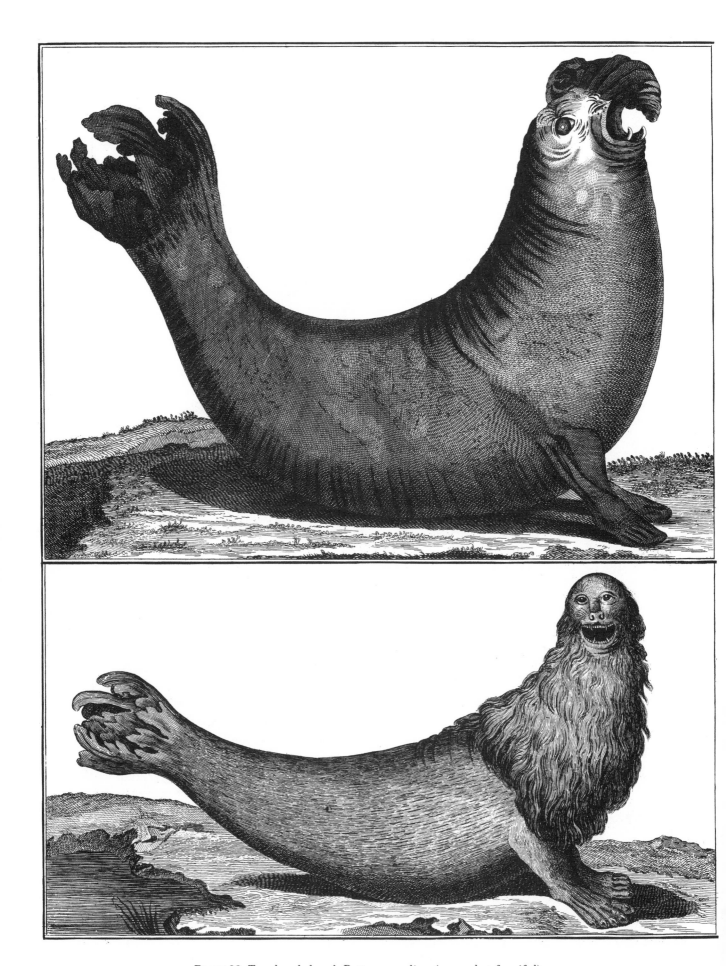

PLATE 22. Top: hooded seal. Bottom: sea lion (somewhat fanciful).

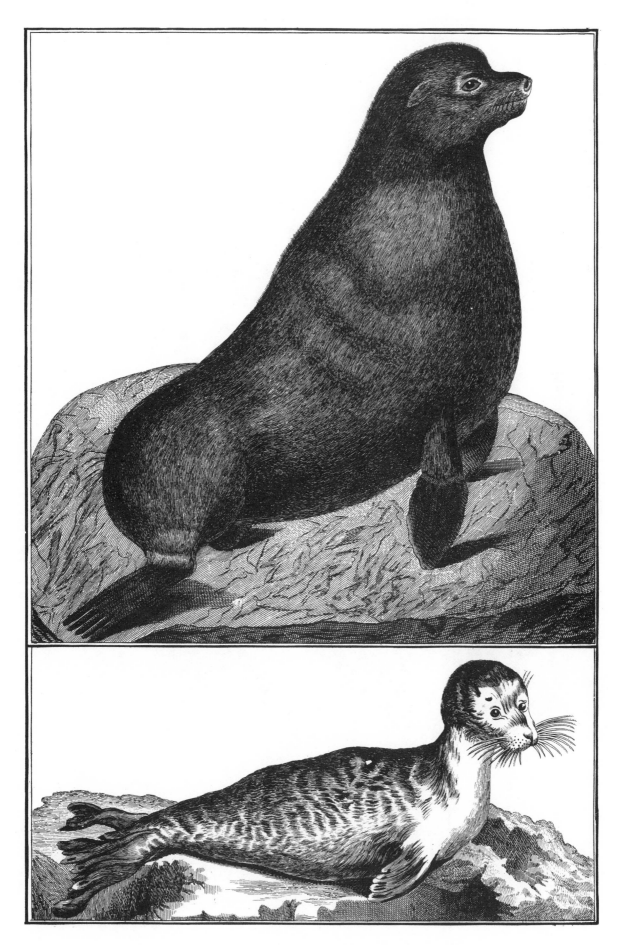

PLATE 23. Two species of seal.

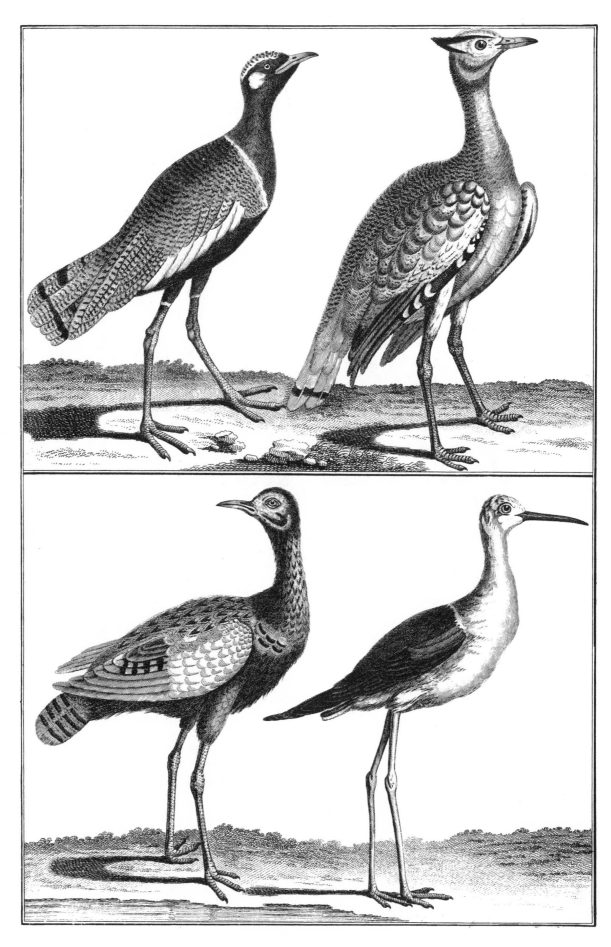

PLATE 24. Top: Two species of bustard. Bottom: (left) another type of bustard, (right) a species of stilt.

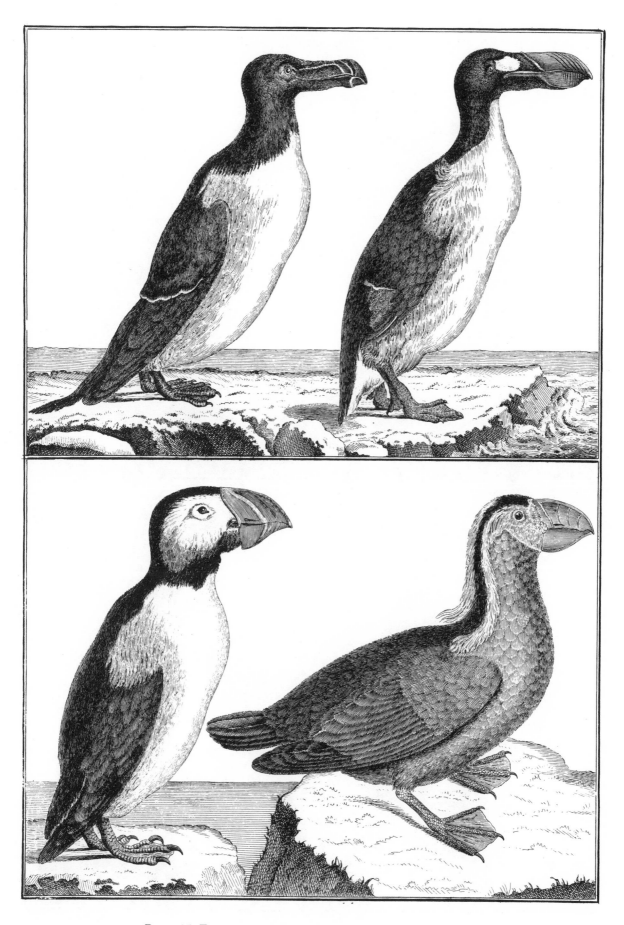

PLATE 25. Top: two species of auk. Bottom: two species of puffin.

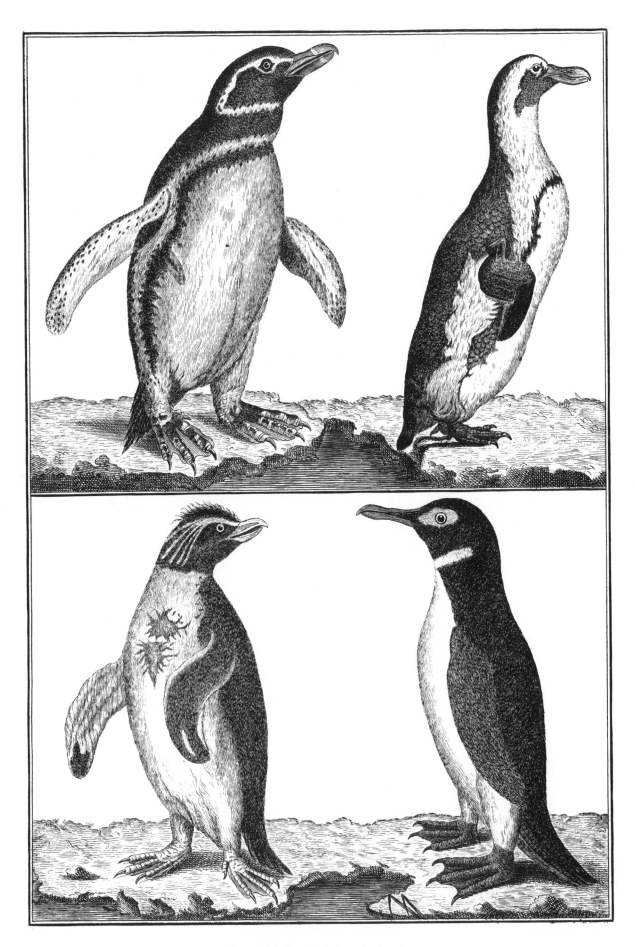

PLATE 26. Four species of penguin.

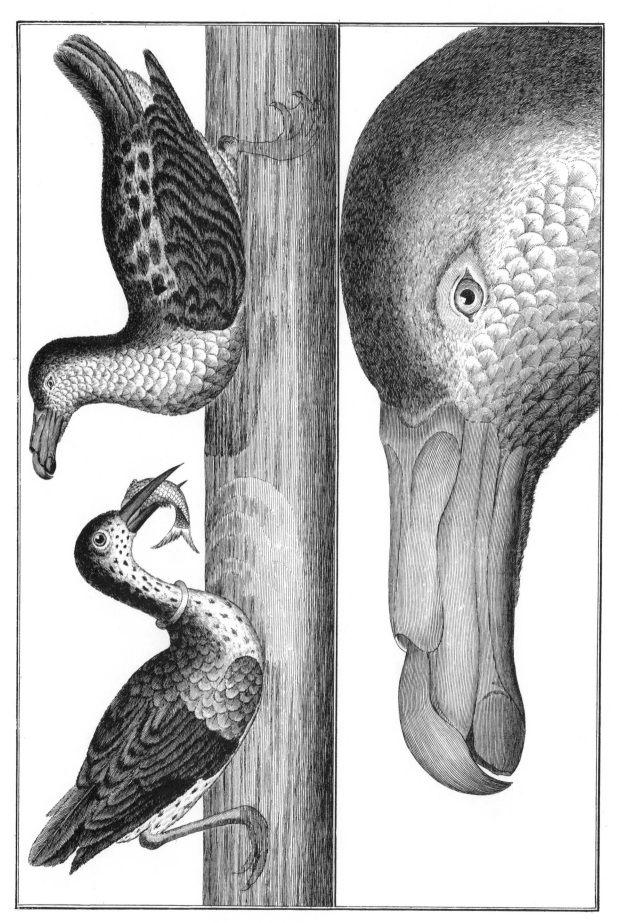

PLATE 27. Top: (left) a type of diver, (right) a species of fulmar. Bottom: head of fulmar, natural size.

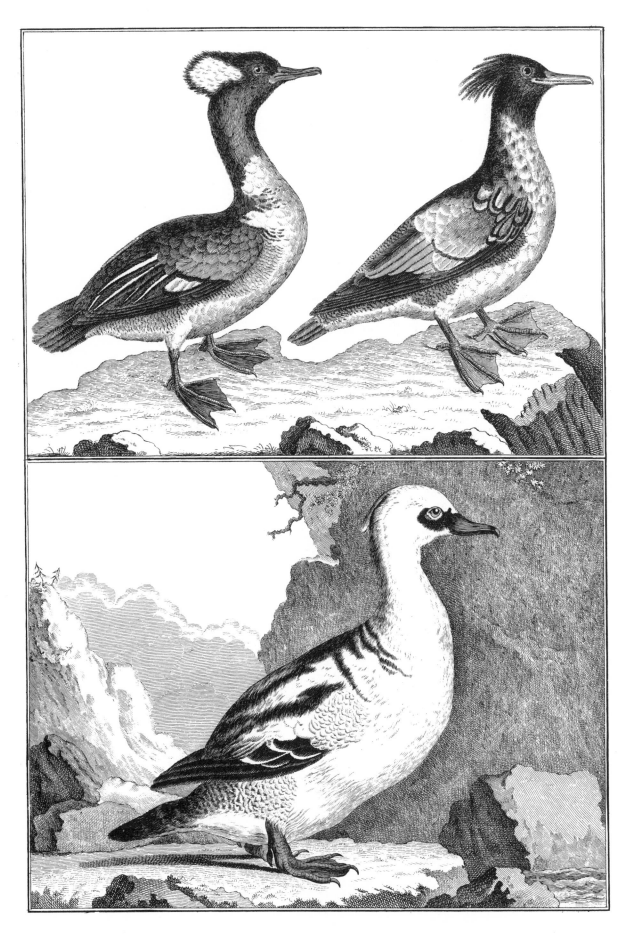

PLATE 28. Top: (left) hooded merganser, (right) red-breasted merganser. Bottom: Bird of the duck family.

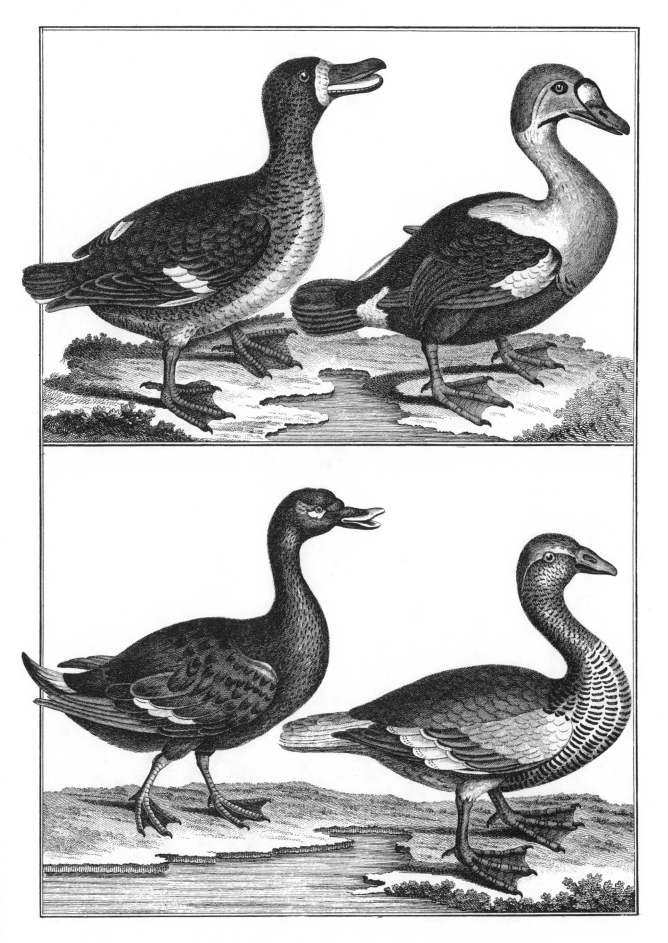

PLATE 29. Various species of wild duck and (bottom right) graylag goose.

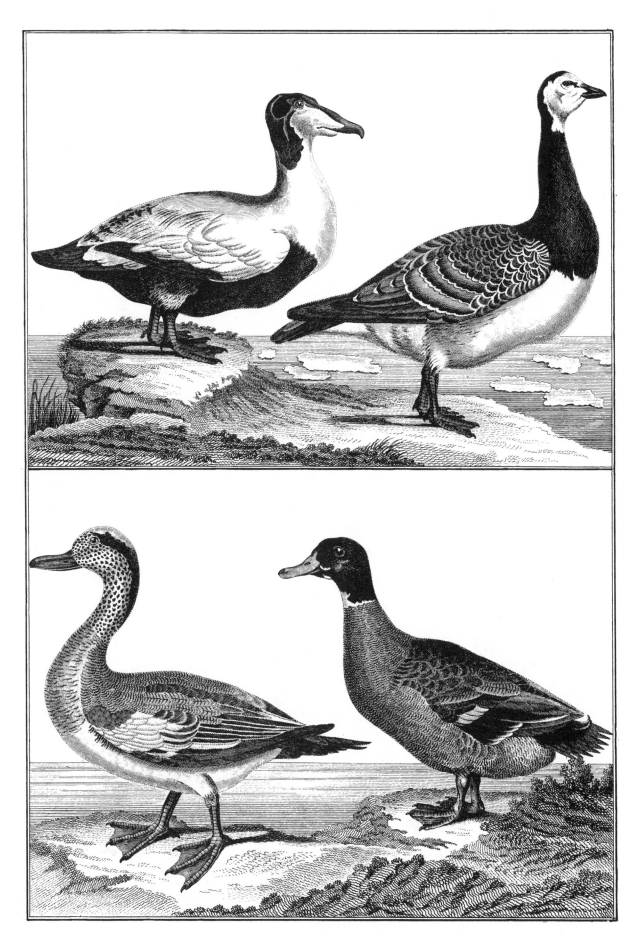

PLATE 30. Top: (left) eider, (right) barnacle goose. Bottom: (left) a species of wild duck, (right) mallard.

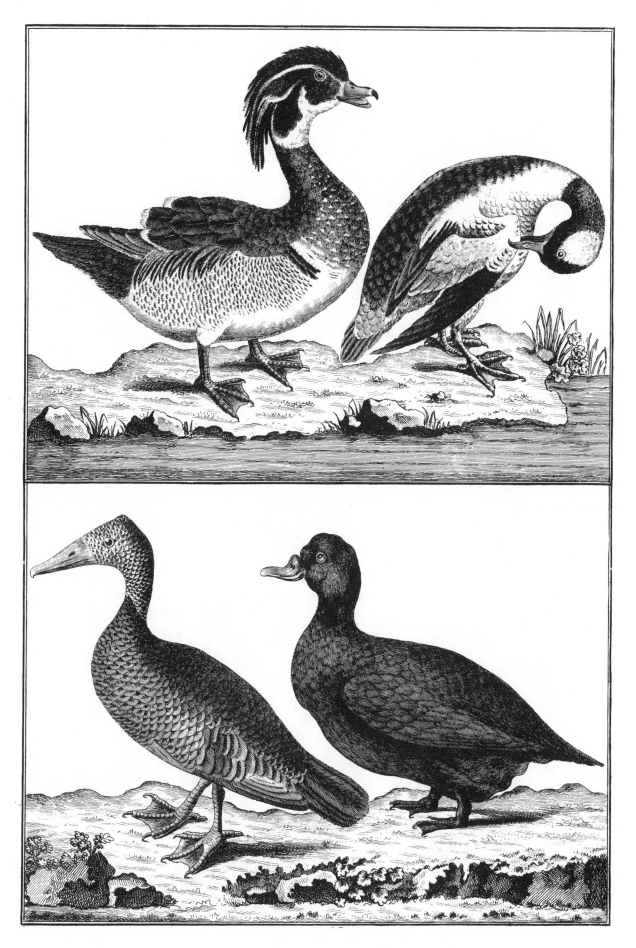

PLATE 31. Four species of wild duck (bottom right: scoter).

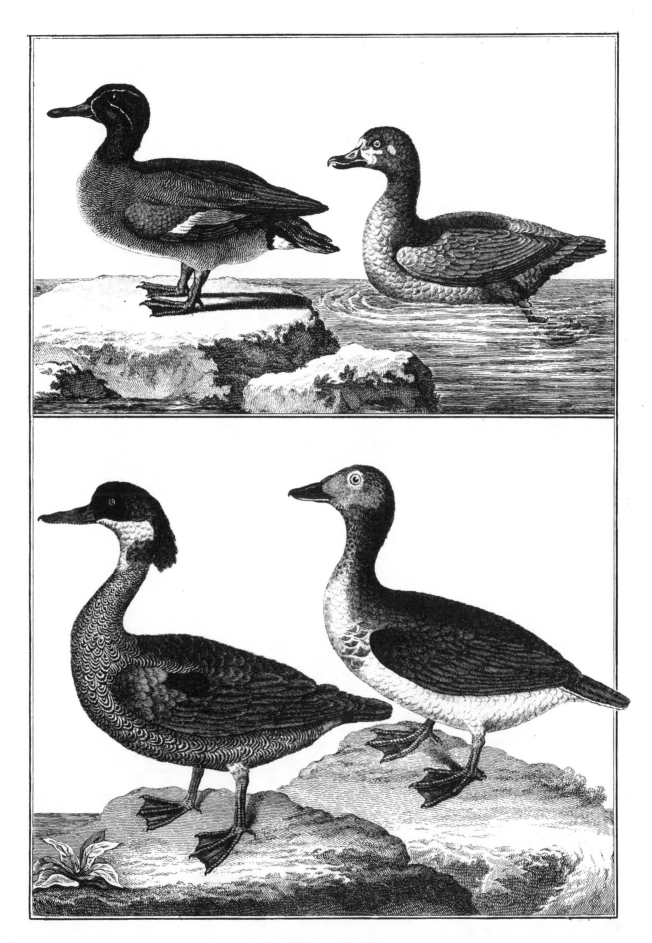

PLATE 32. Four species of teal.

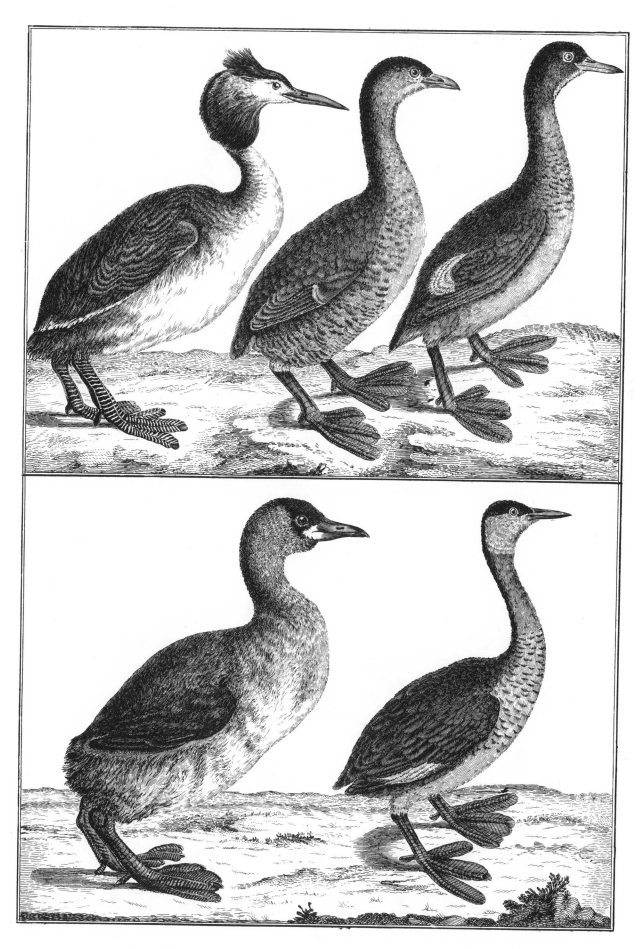

PLATE 33. Five species of grebe, including (top left) the great crested grebe.

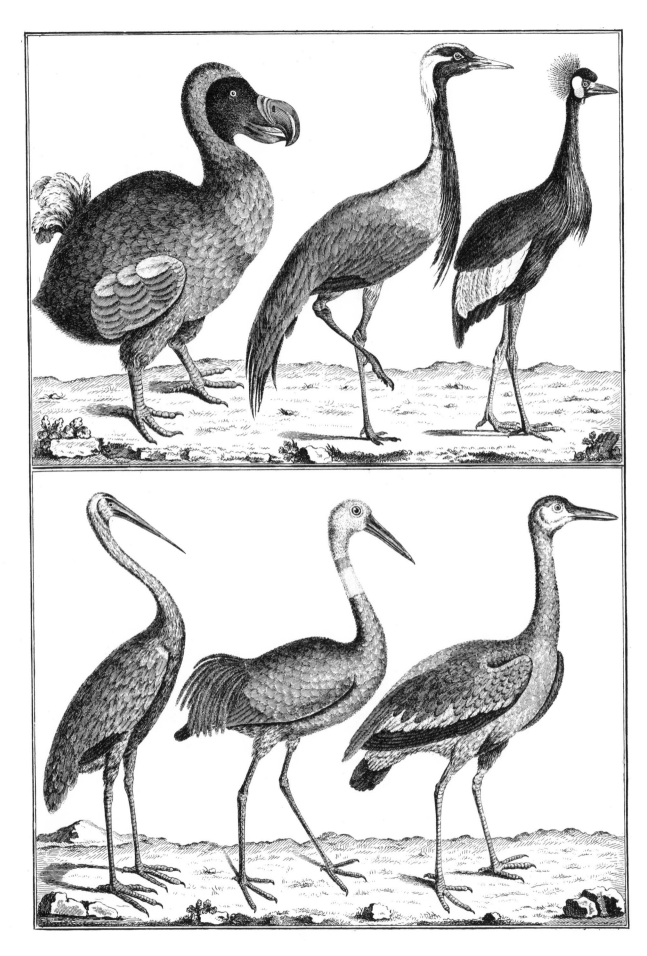

PLATE 34. Top: (left to right) dodo, demoiselle crane, crowned crane. Bottom: three other species of crane.

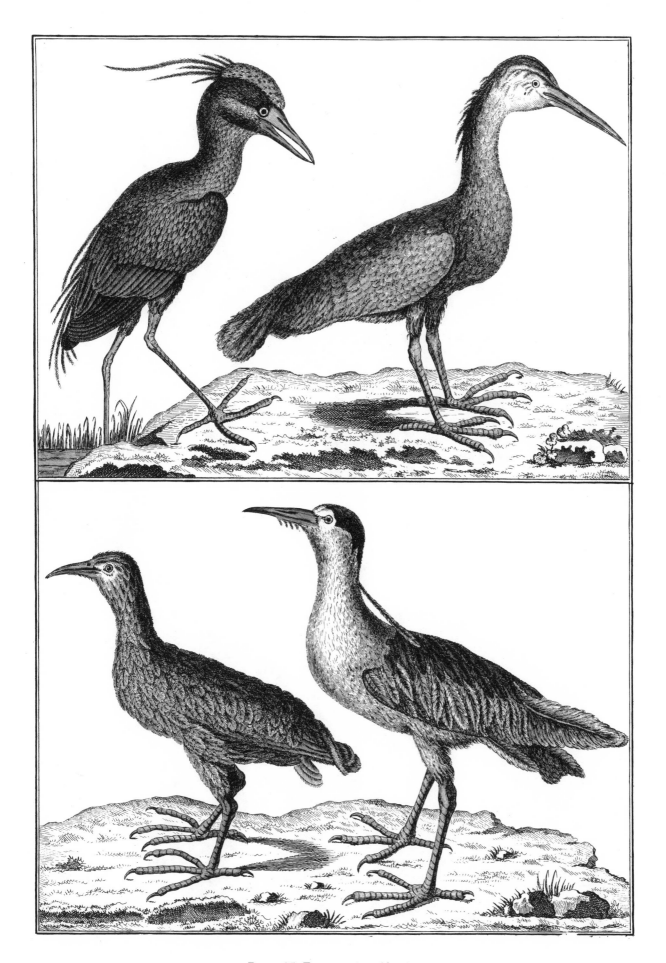

PLATE 35. Four species of heron.

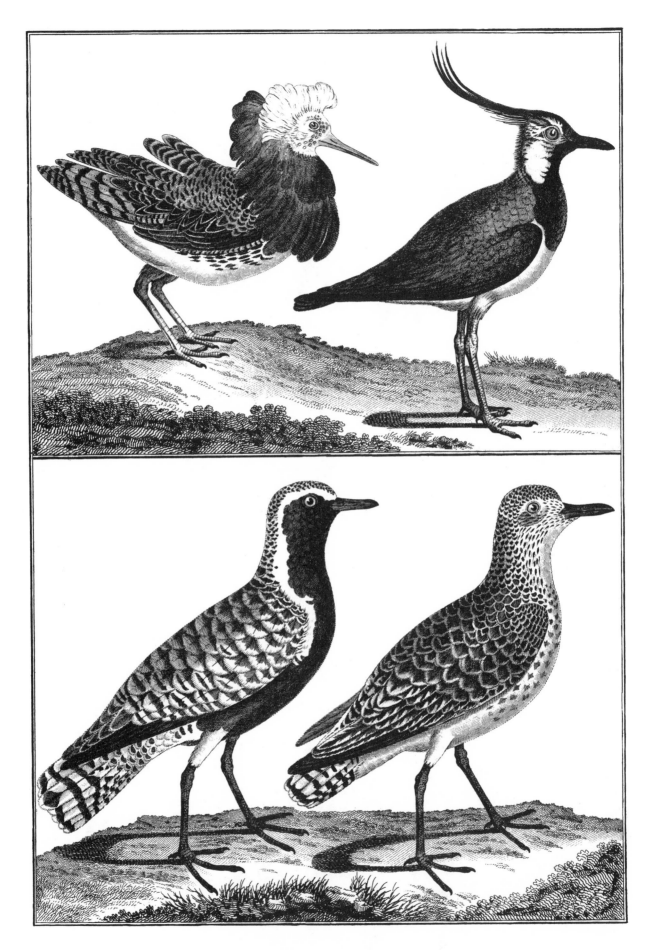

PLATE 36. Top: (left) ruff, (right) lapwing. Bottom: two species of plover.

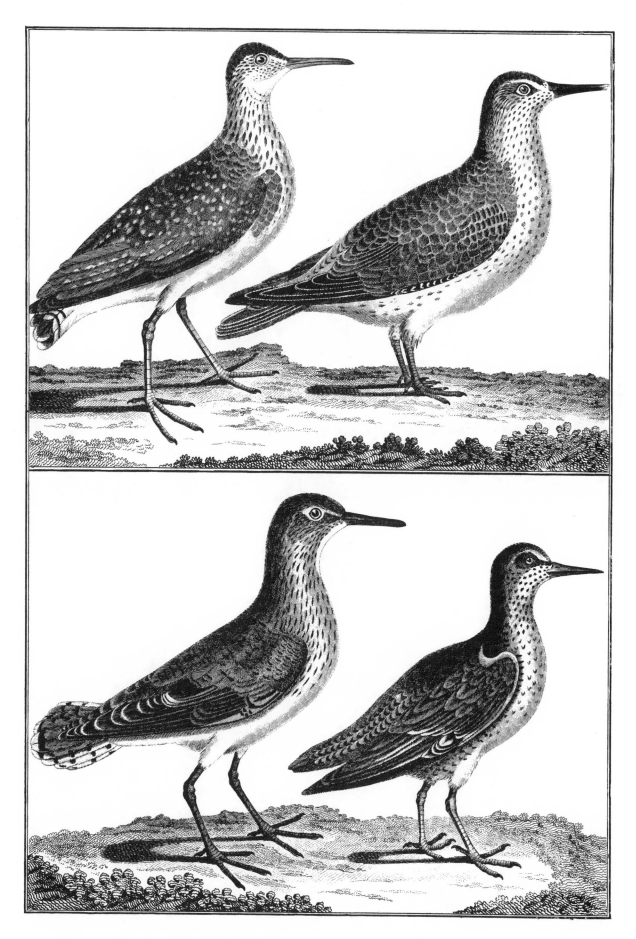

PLATE 37. Four species of sandpiper (bottom right: knot).

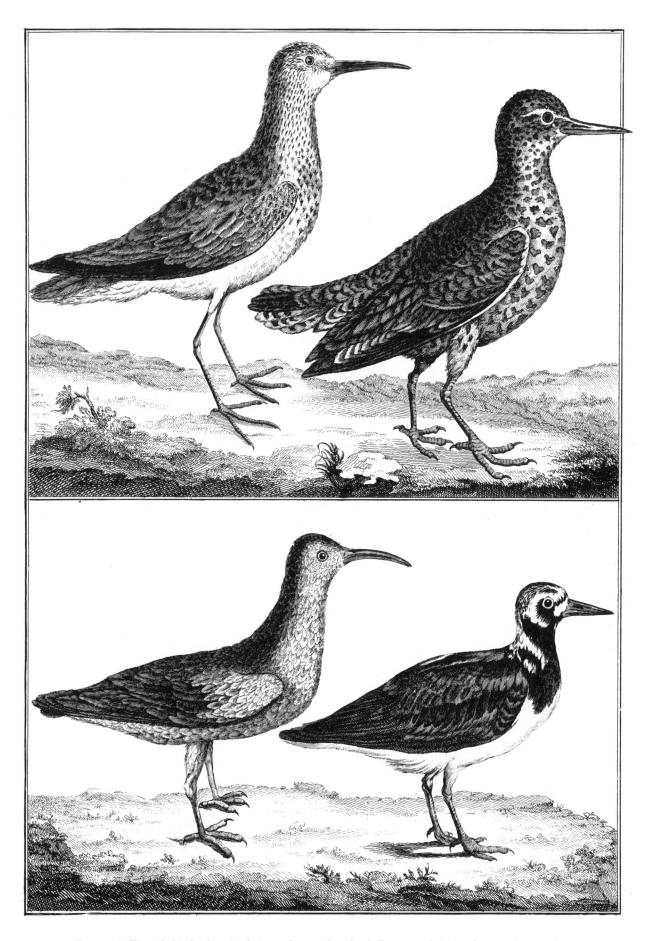

PLATE 38. Top: (left) dunlin, (right) another wading bird. Bottom: (left) curlew sandpiper (?), (right) turnstone.

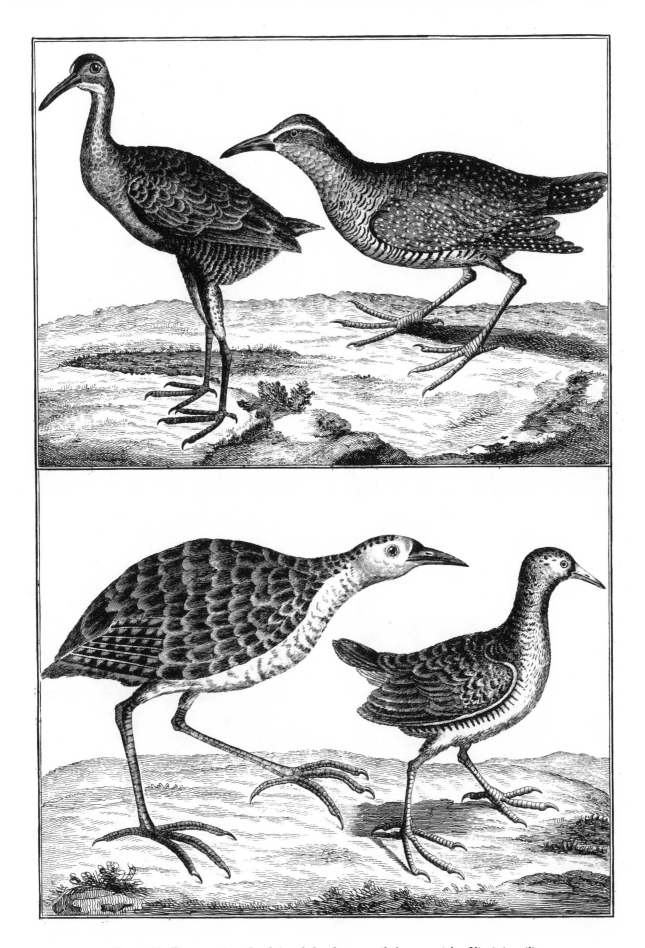

PLATE 39. Four species of rail (top left: clapper rail; bottom right: Virginia rail).

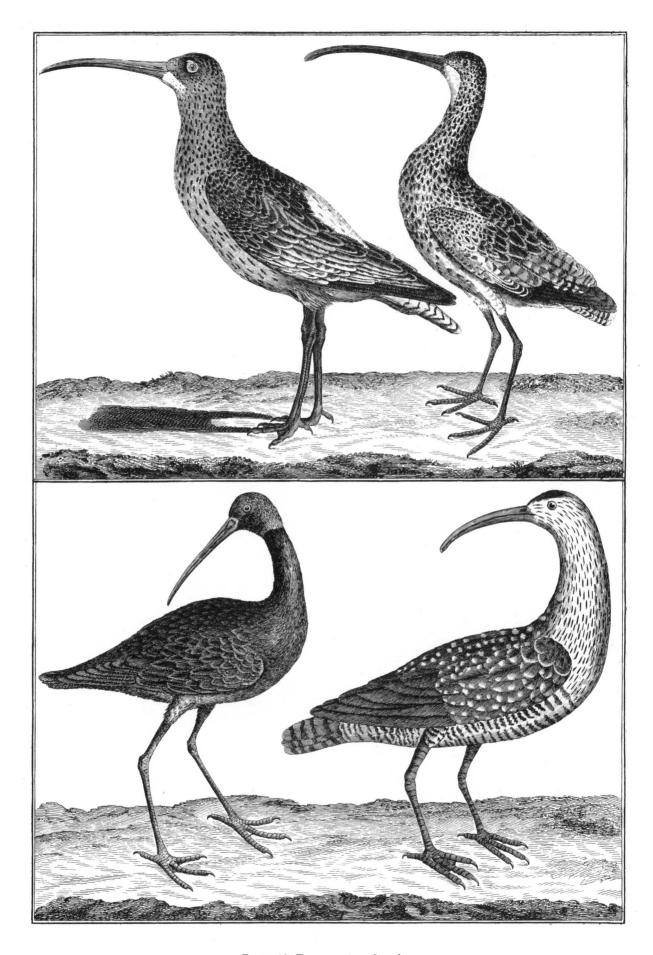

PLATE 40. Four species of curlew.

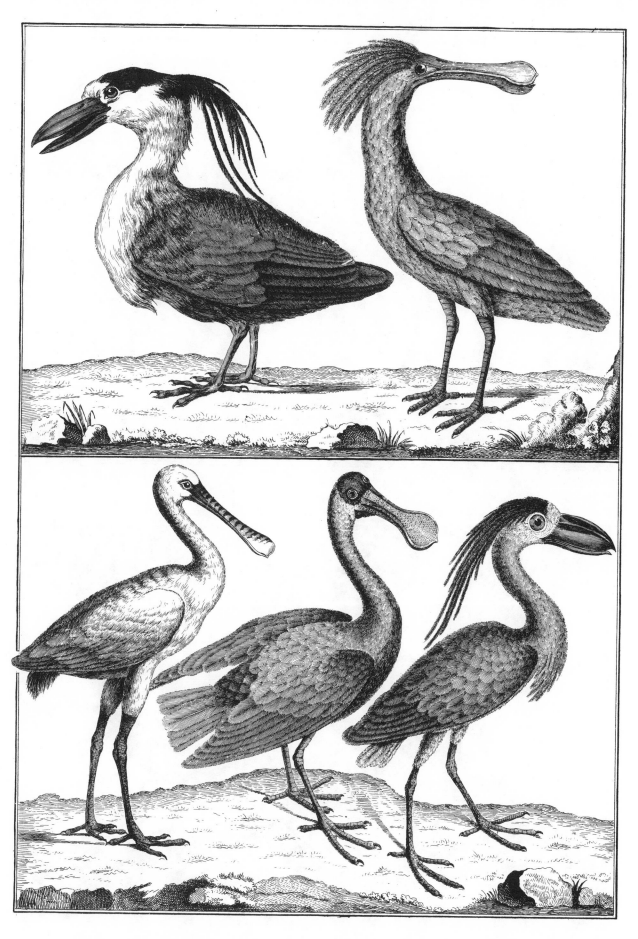

PLATE 41. Top: (left) boatbill, (right) a species of spoonbill. Bottom: (left) a species of spoonbill, (middle) roseate spoonbill, (right) a species of boatbill.

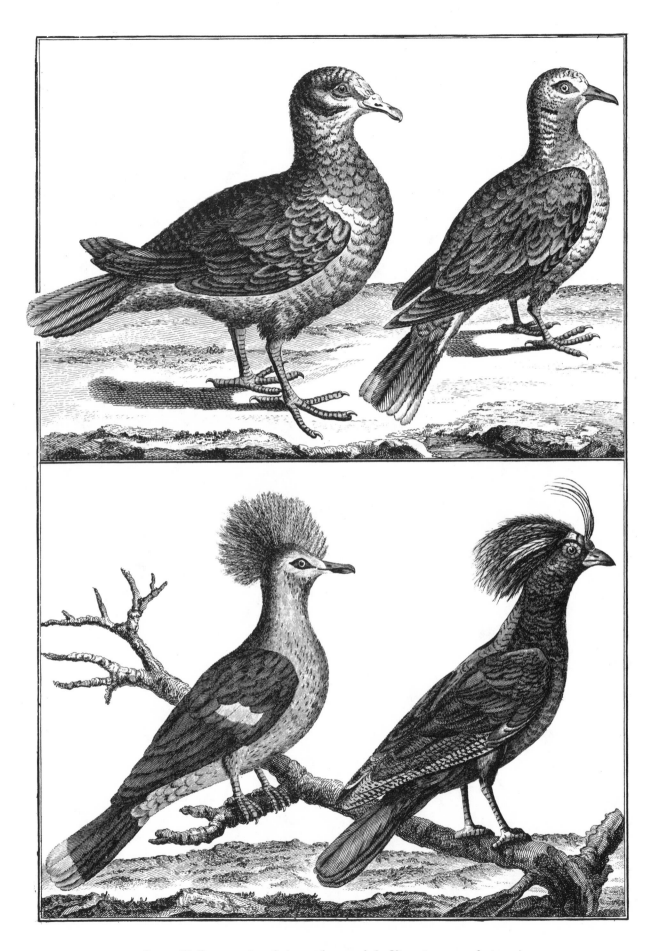

PLATE 42. Four species of pigeon (bottom left: Victoria crowned pigeon).

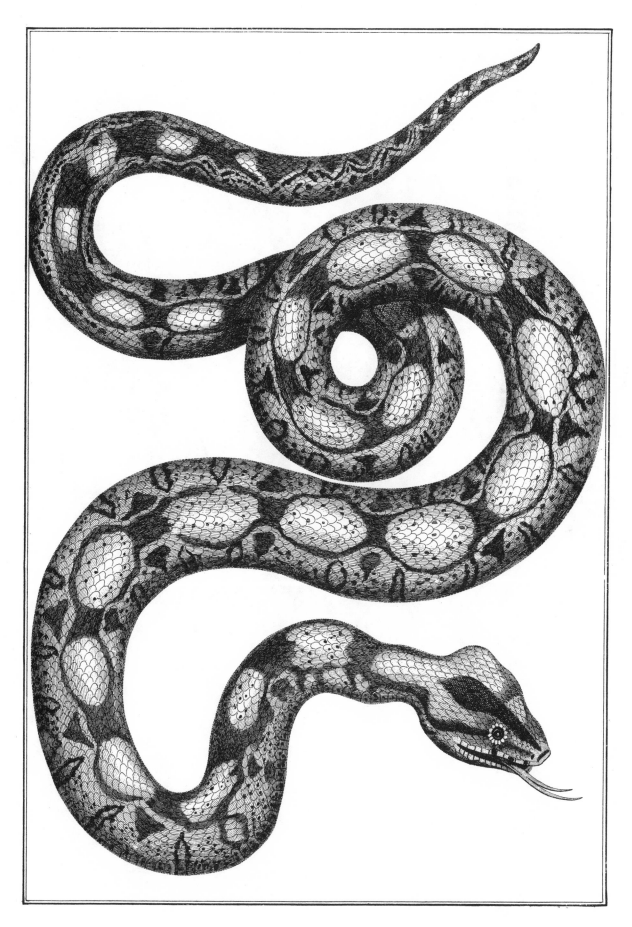

PLATE 43. A species of boa (?).

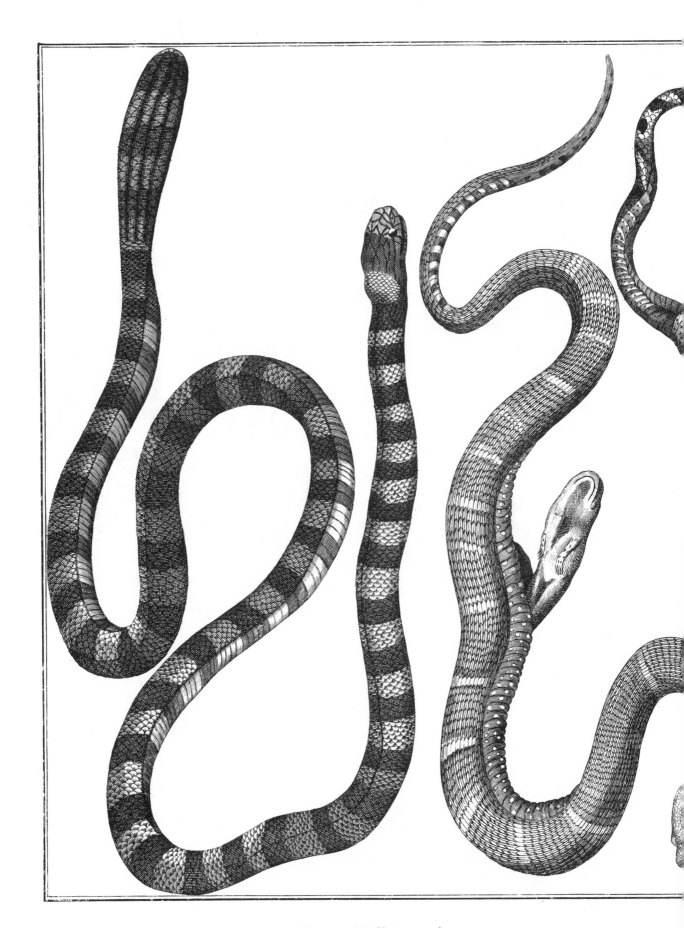

PLATE 44/45. Various snakes.

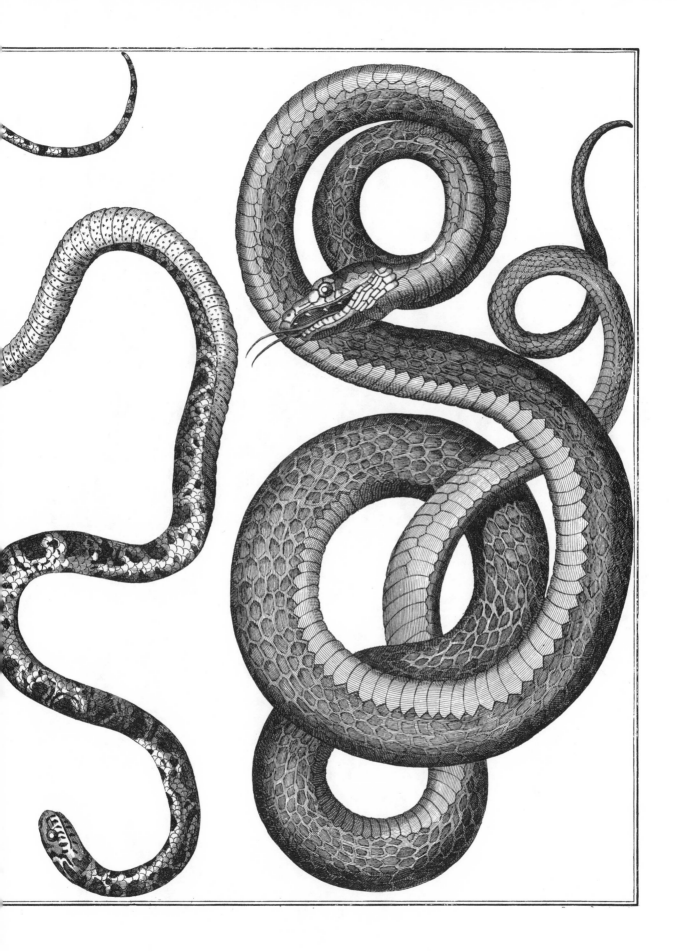

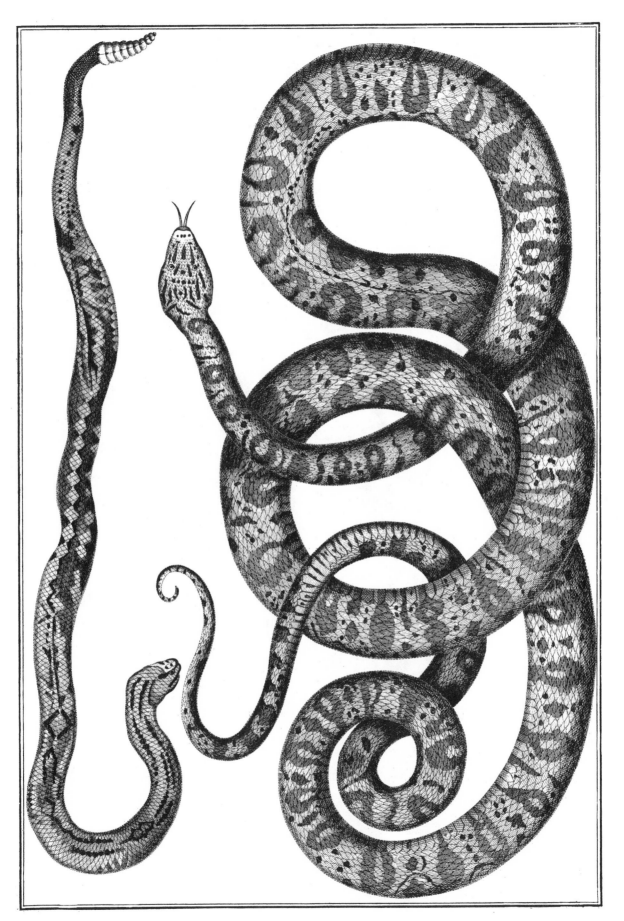

PLATE 46. Two species of python (?).

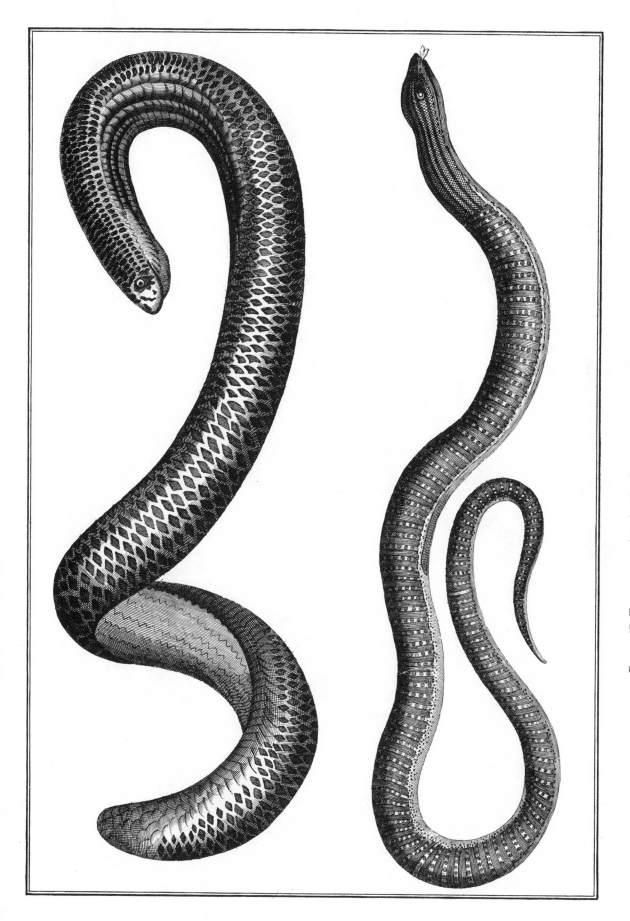

PLATE 47. Top: a type of snake (?). Bottom: glass snake (actually a lizard).

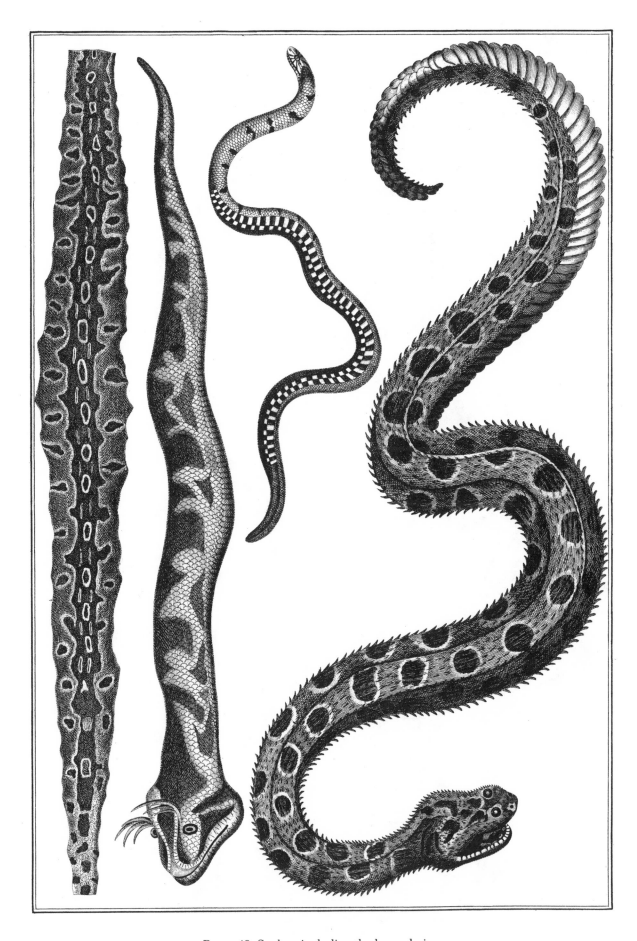

PLATE 48. Snakes, including the horned viper.

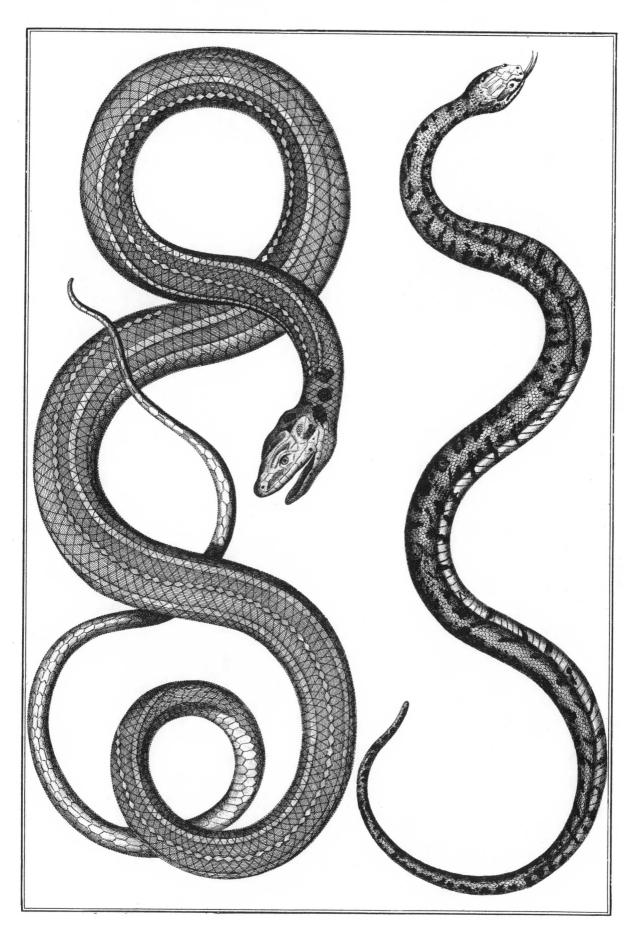

PLATE 49. Snakes.

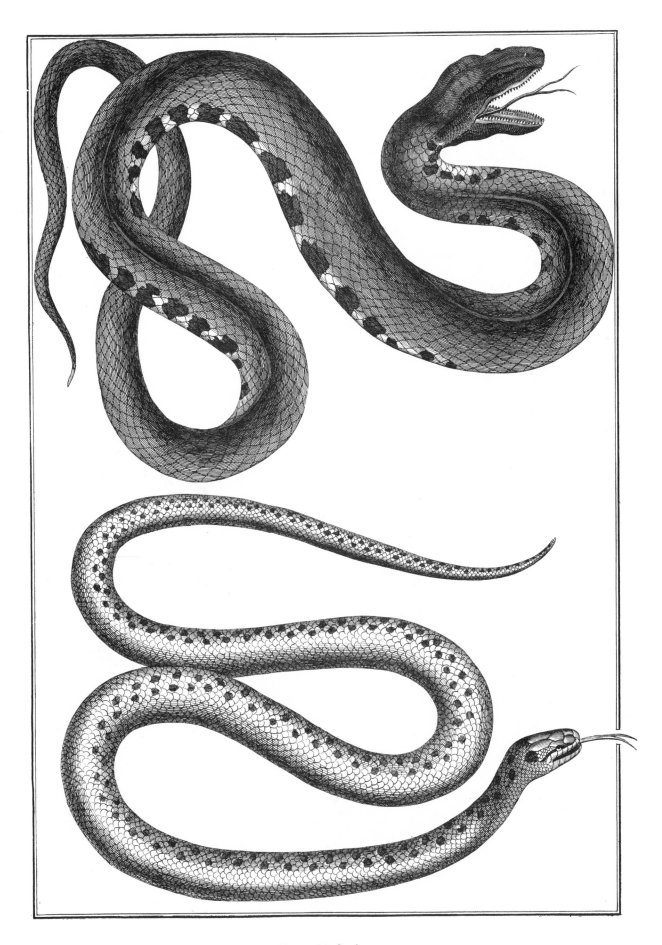

Plate 50. Snakes.

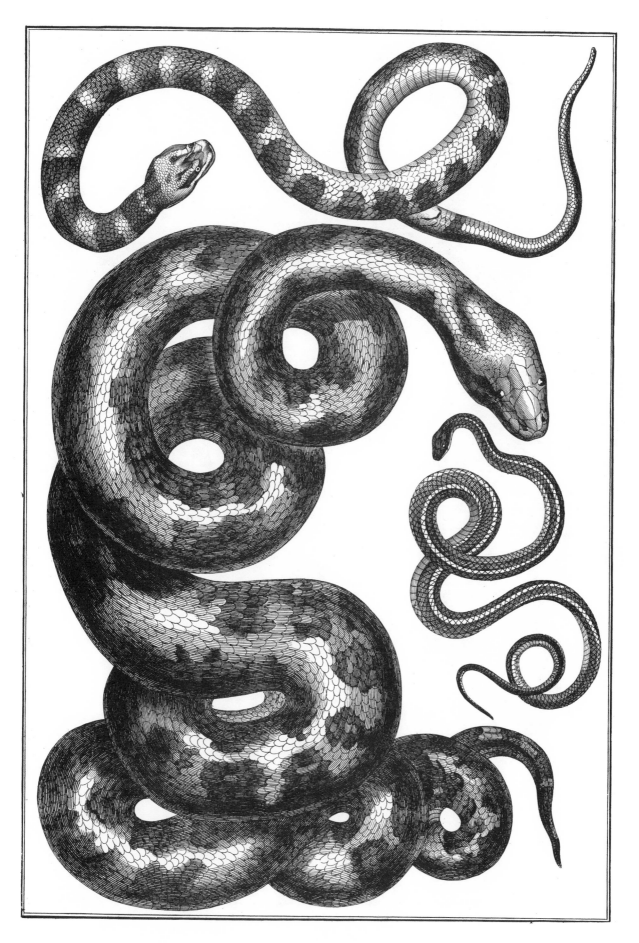

PLATE 51. Snakes, the largest one being the Indian python.

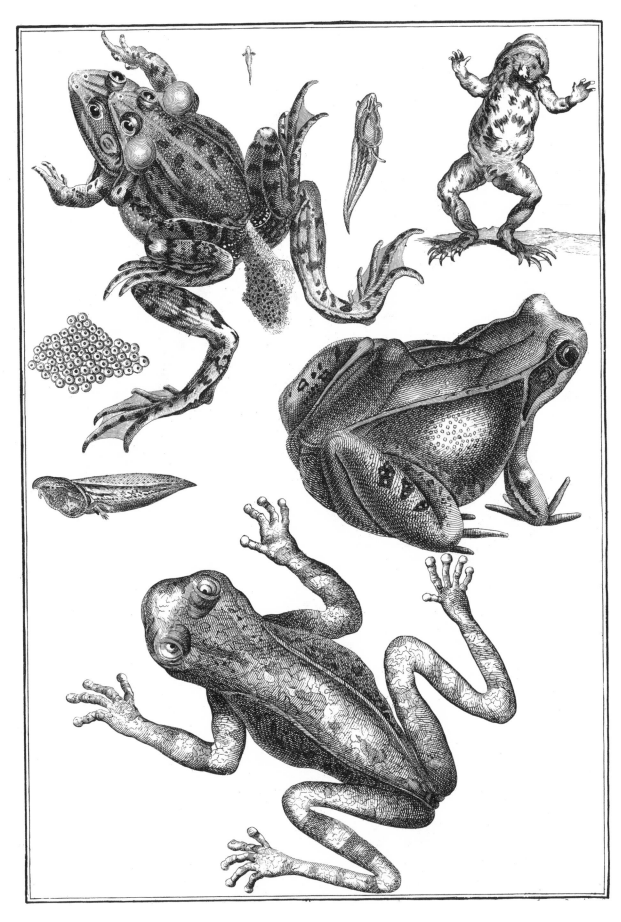

PLATE 52. Various frogs. At the upper right, a male fertilizes the eggs laid by the female; eggs; tadpoles.

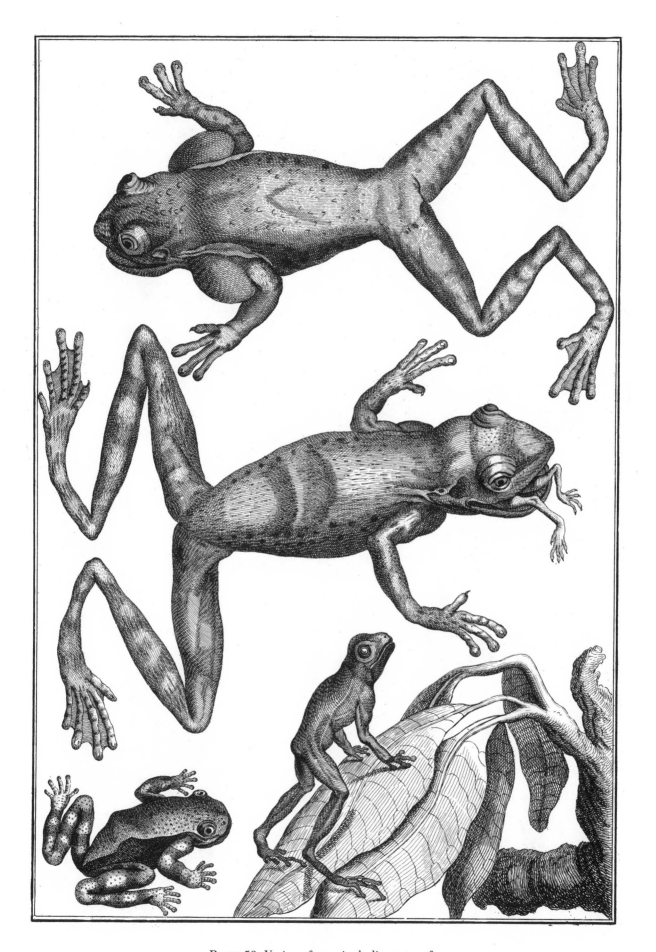

PLATE 53. Various frogs, including a tree frog.

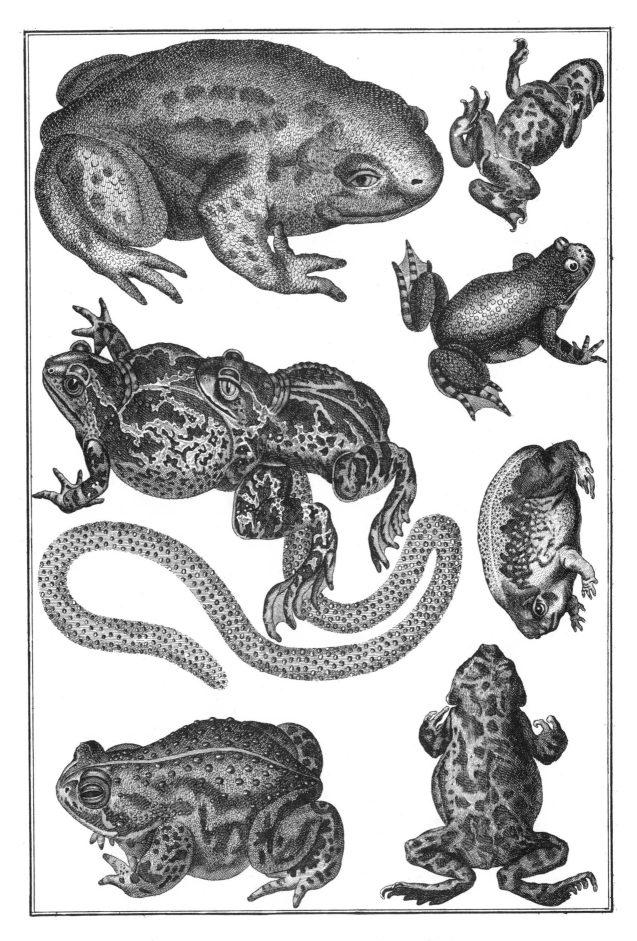

PLATE 54. Various toads, with a scene of egg fertilization.

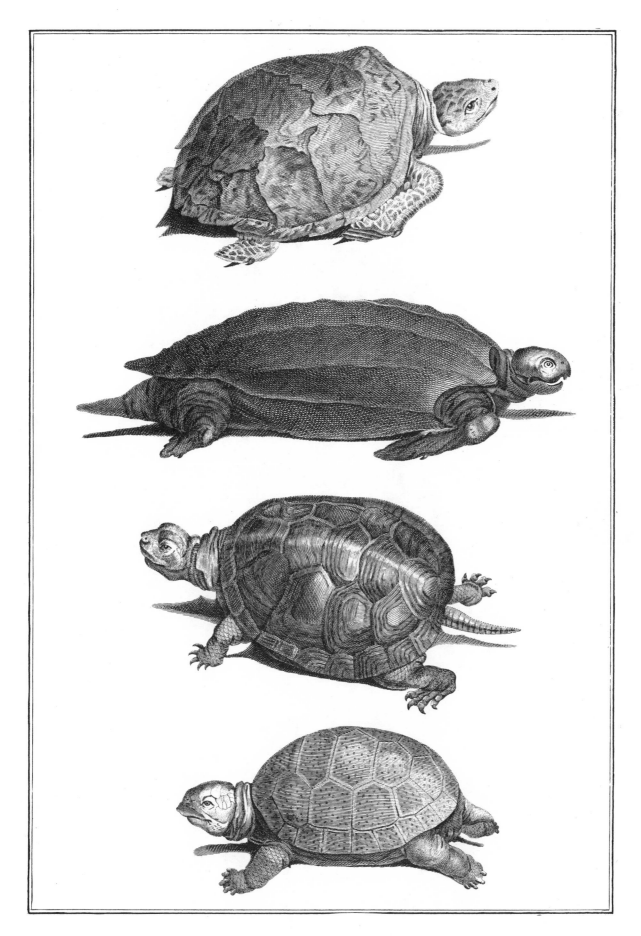

PLATE 55. Various turtles and tortoises.

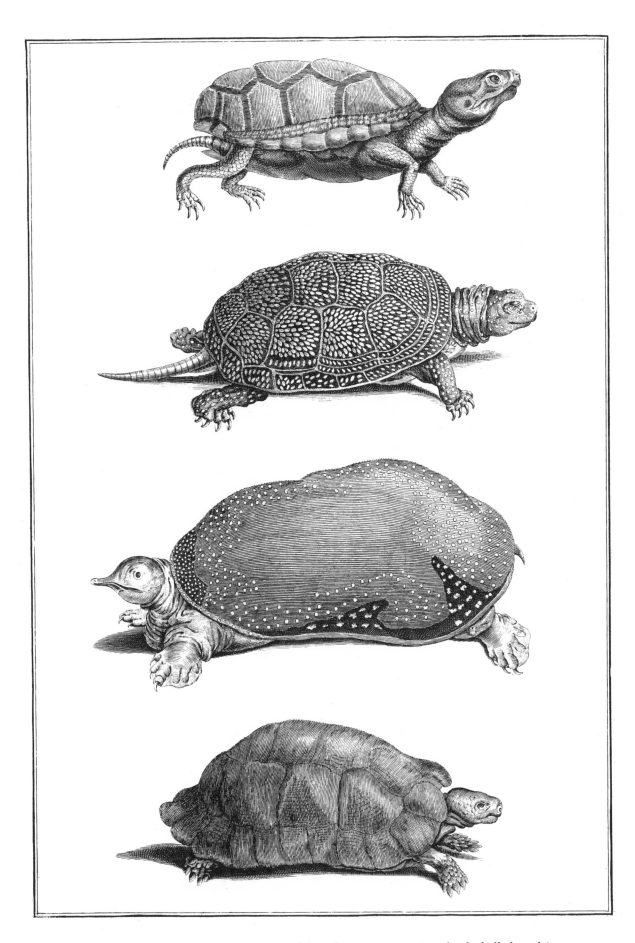

PLATE 56. Turtles and tortoises (second from bottom is a species of soft-shelled turtle).

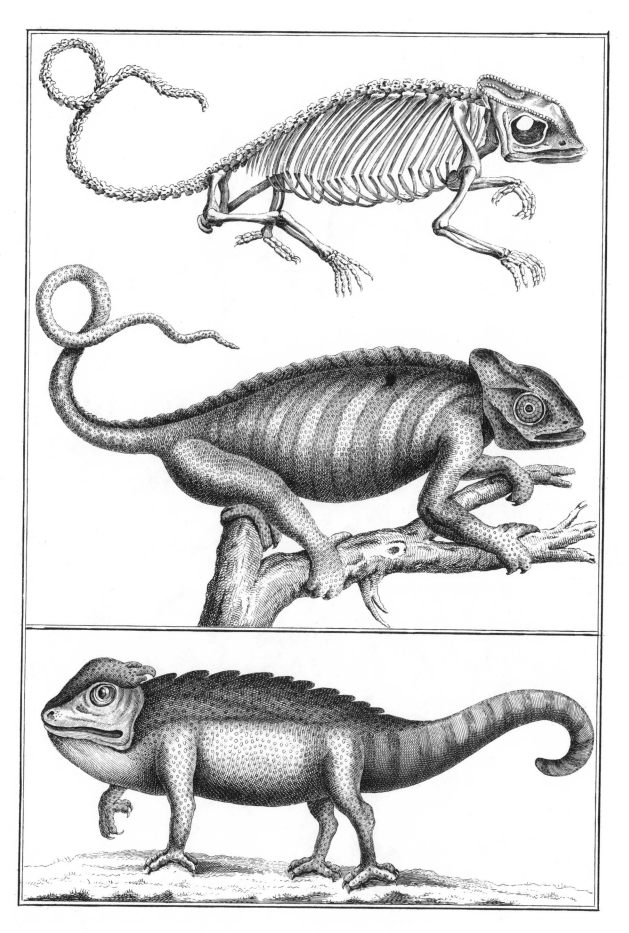

PLATE 57. Two species of chameleon, and a skeleton.

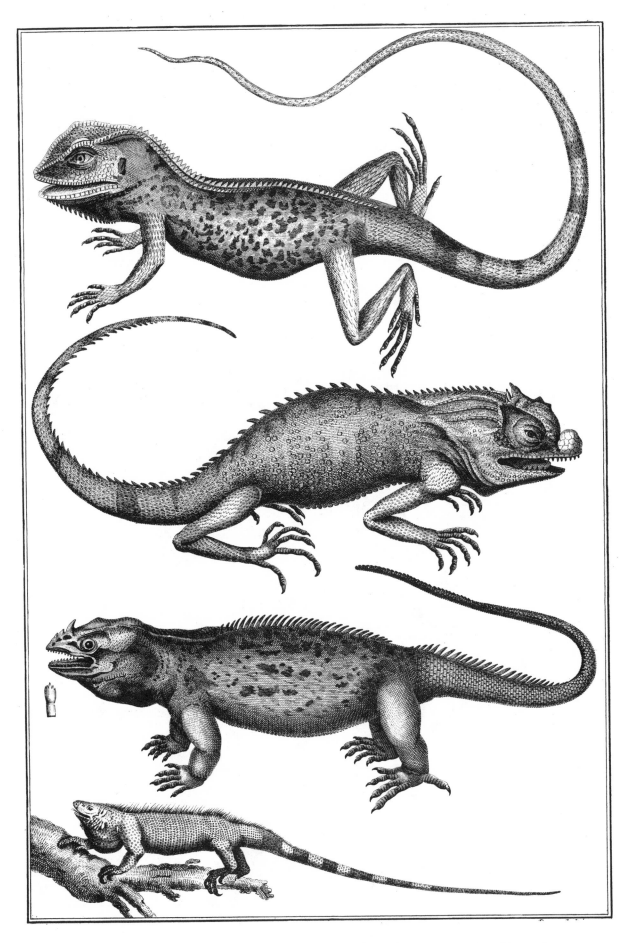

PLATE 58. Various lizards, one with a tooth at natural size (bottom: a species of iguana).

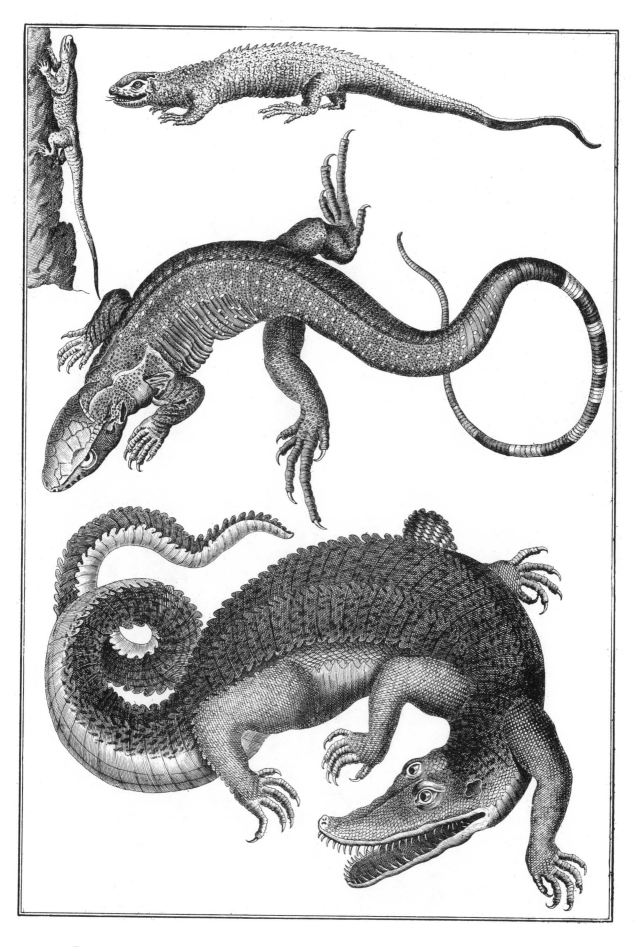

PLATE 59. Top three: various lizards (upper horizontal one is a species of monitor). Bottom: either a mastigure or a type of alligator (somewhat fanciful).

PLATE 60. A species of caiman.

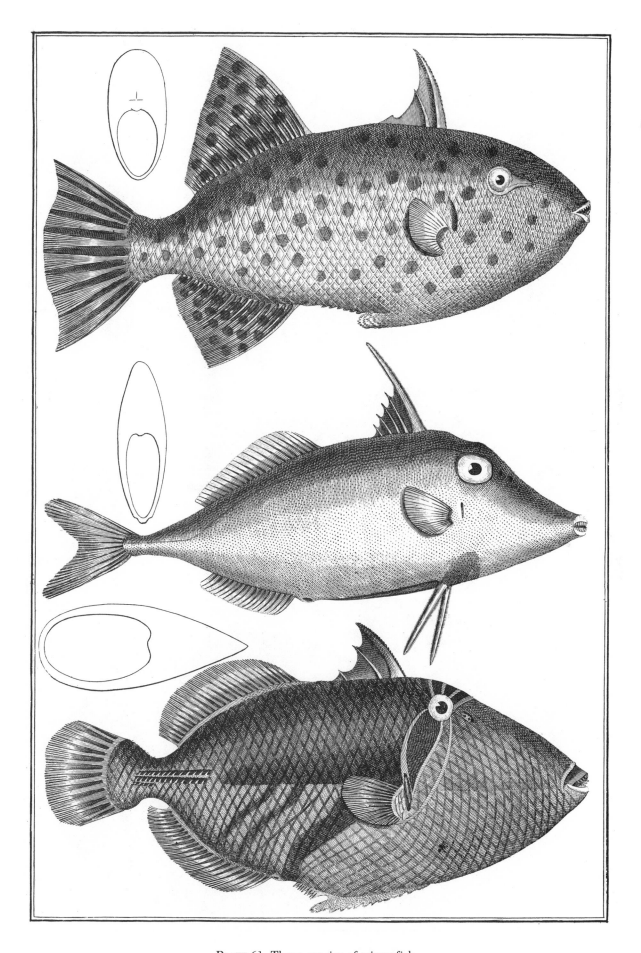

PLATE 61. Three species of triggerfish.

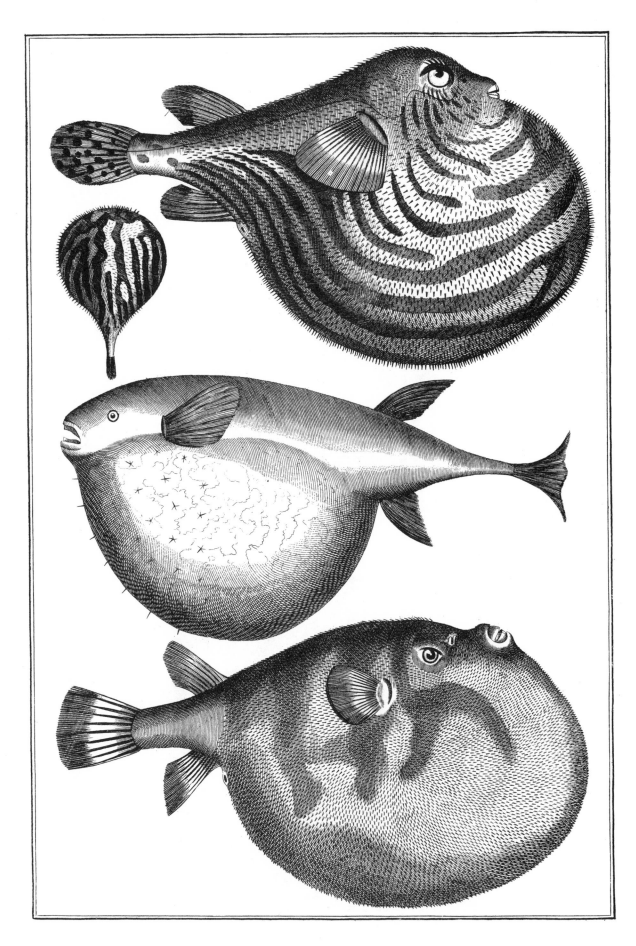

PLATE 62. Various species of puffer.

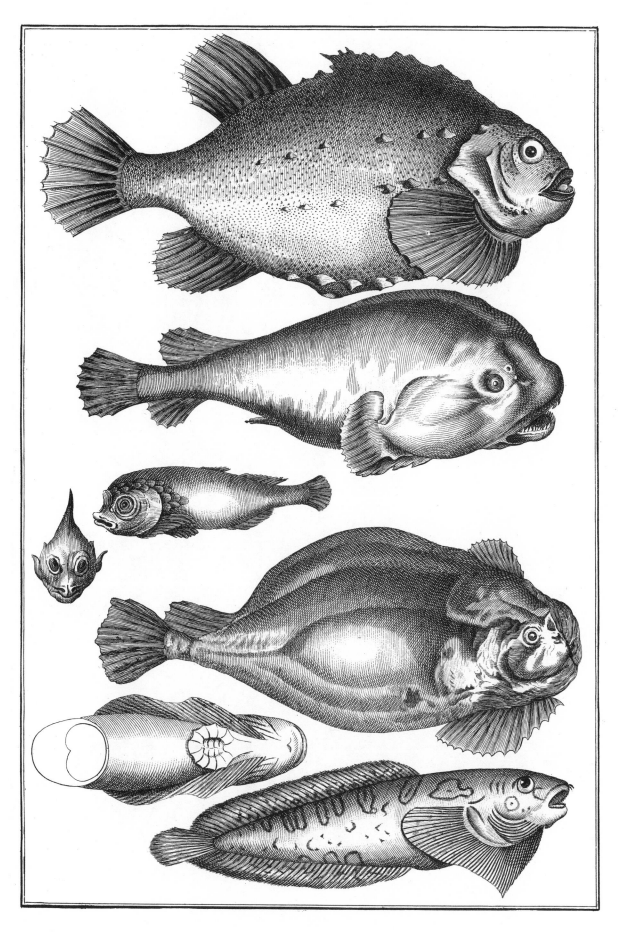

PLATE 63. Various lumpfishes and snailfishes, with a suction disk. (Top: lumpfish; bottom: sea snail).

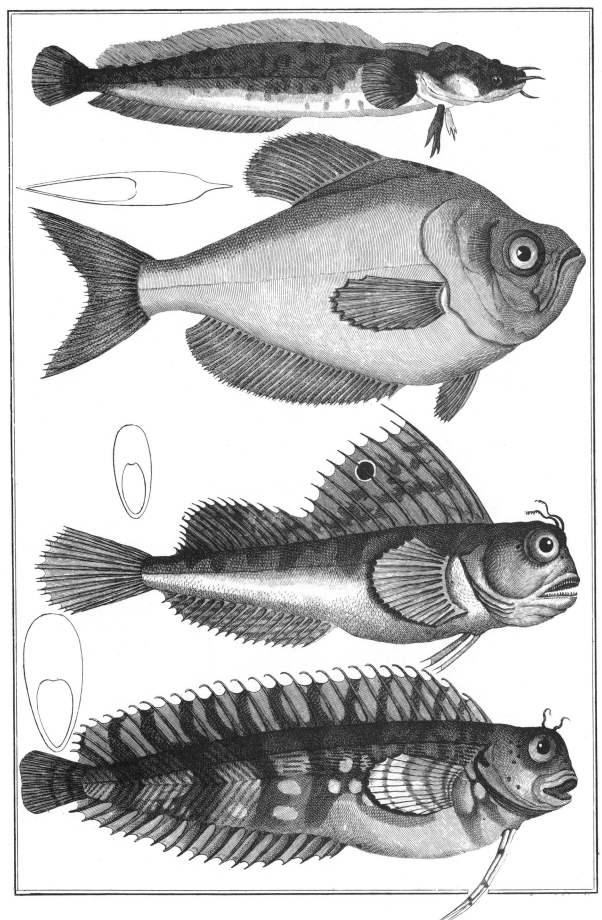

PLATE 64. Fish (top: a species of catfish; second from bottom: a species of sea robin?).

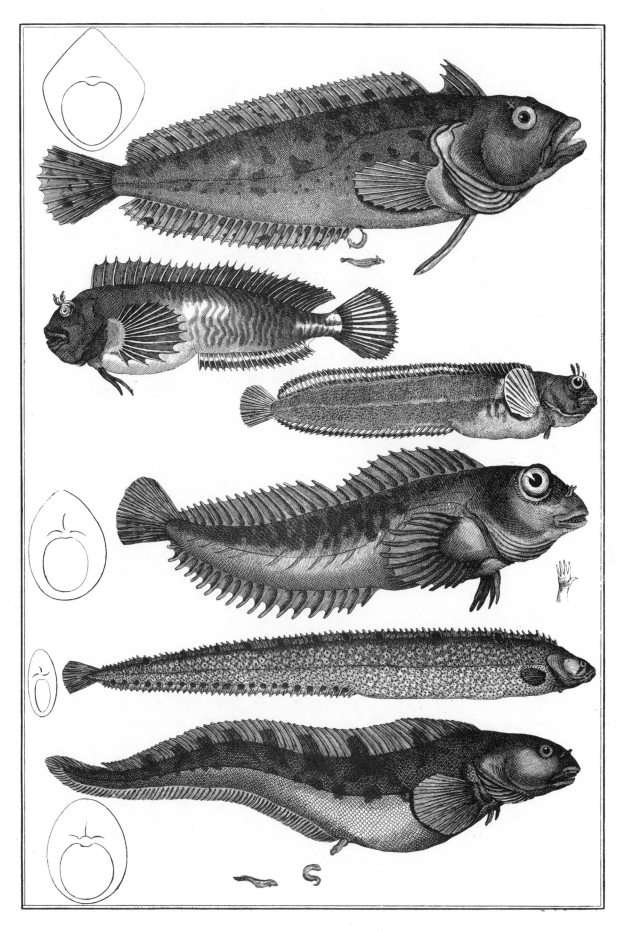

PLATE 65. Fish (top: wolffish?; second from top: blenny?; third from top: prickleback?; second from bottom: gunnel; bottom: viviparous eelpout giving birth).

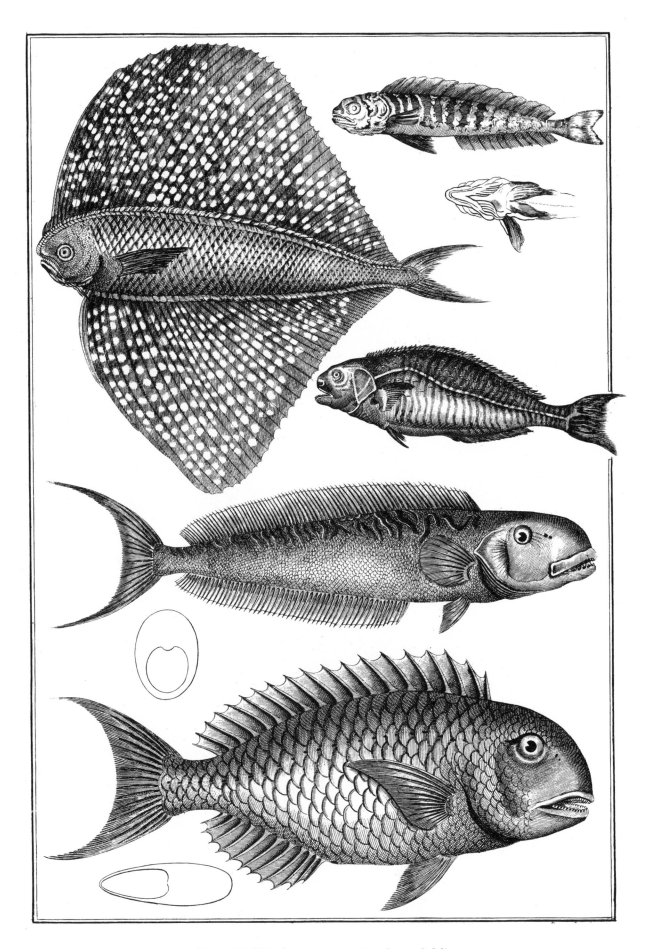

PLATE 66. Fish (bottom: a species of razorfish?).

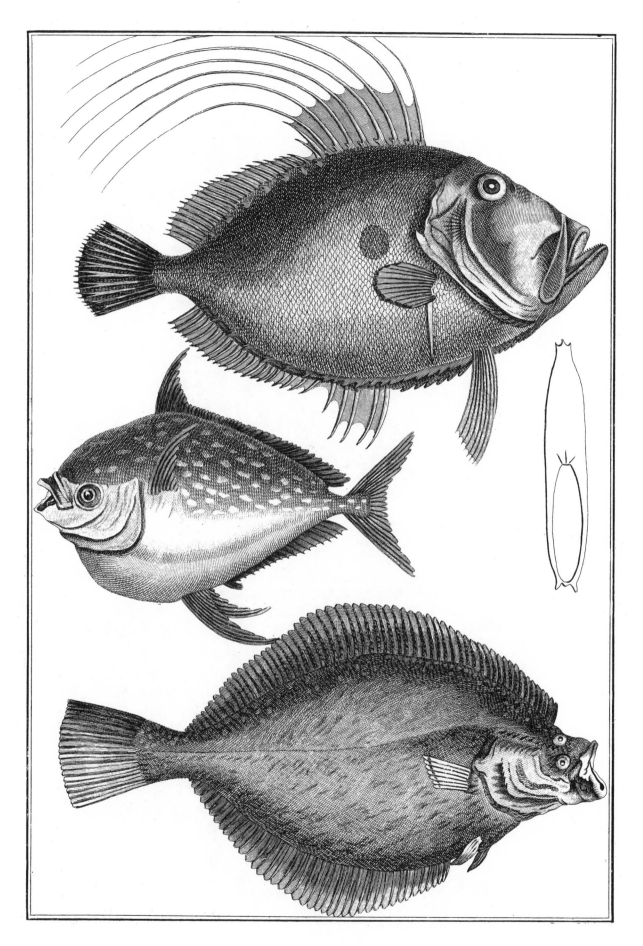

PLATE 67. Top to bottom: John Dory; ?; flounder.

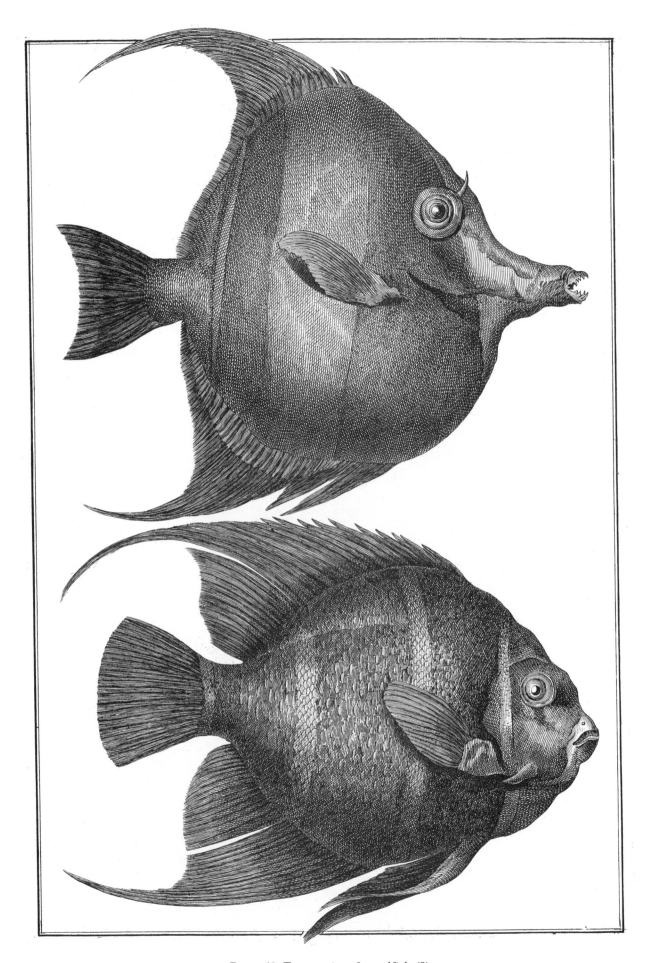

PLATE 68. Two species of angelfish (?).

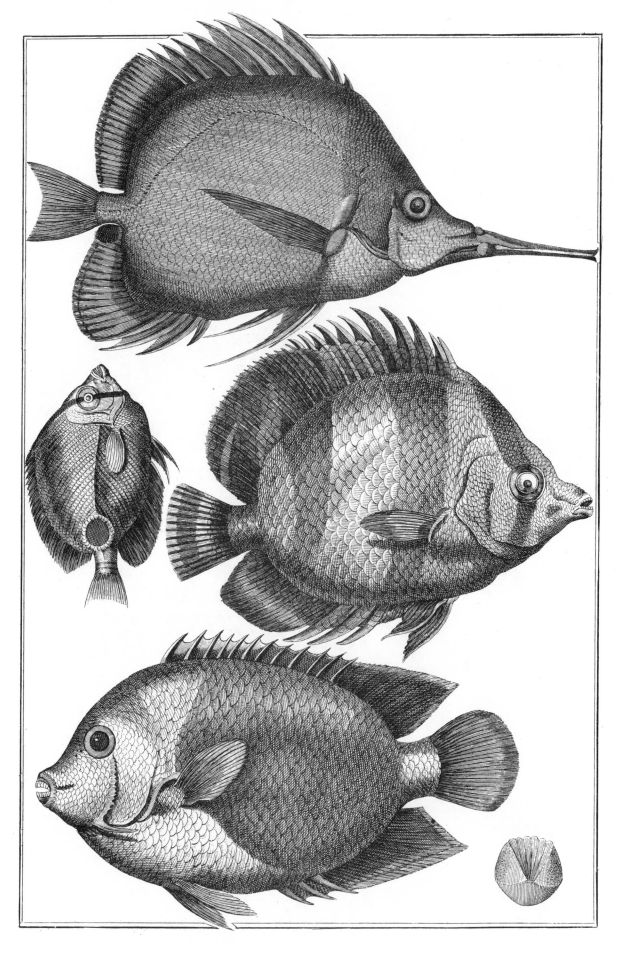

PLATE 69. Top: forceps butterflyfish. Others: species of sunfish (?). Bottom right: a scale, magnified.

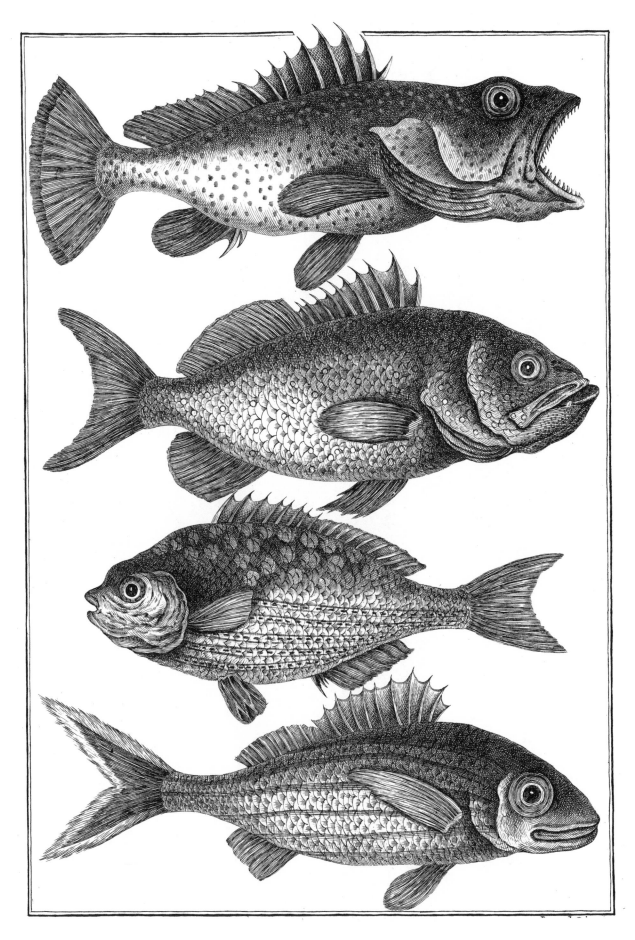

PLATE 70. Various species of sea bass (?).

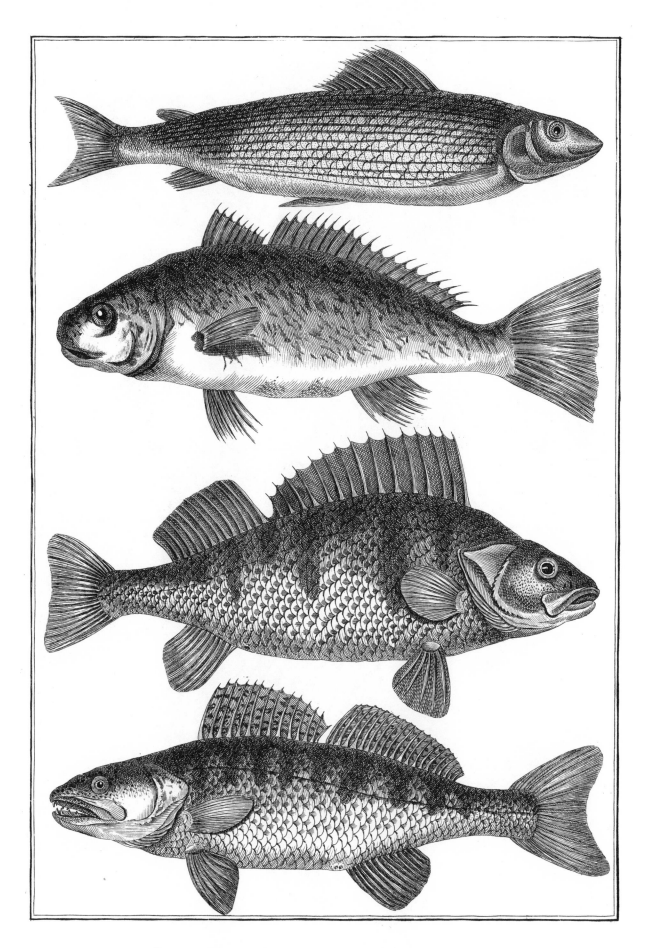

PLATE 71. Top to bottom: a grayling; ?; yellow perch; walleye (?).

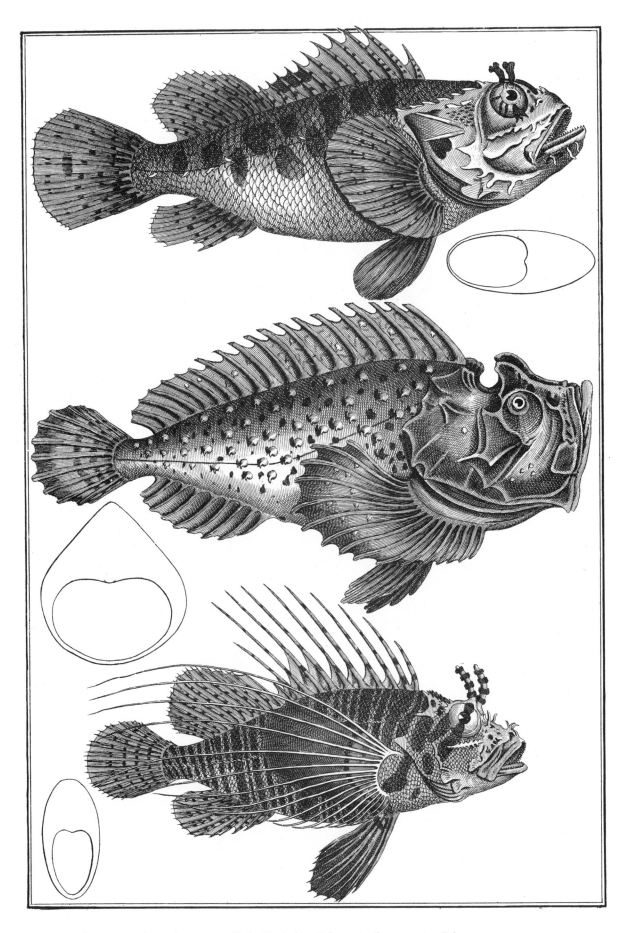

PLATE 72. Top to bottom: redfish (?); ?; lionfish or similar scorpionfish.

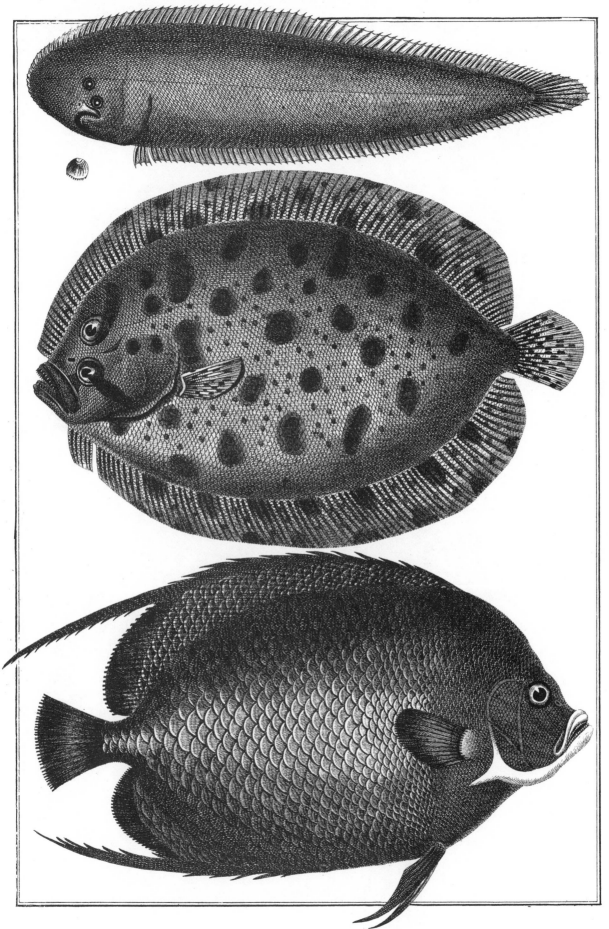

PLATE 73. Top to bottom: tonguefish; topknot or brill; ?.

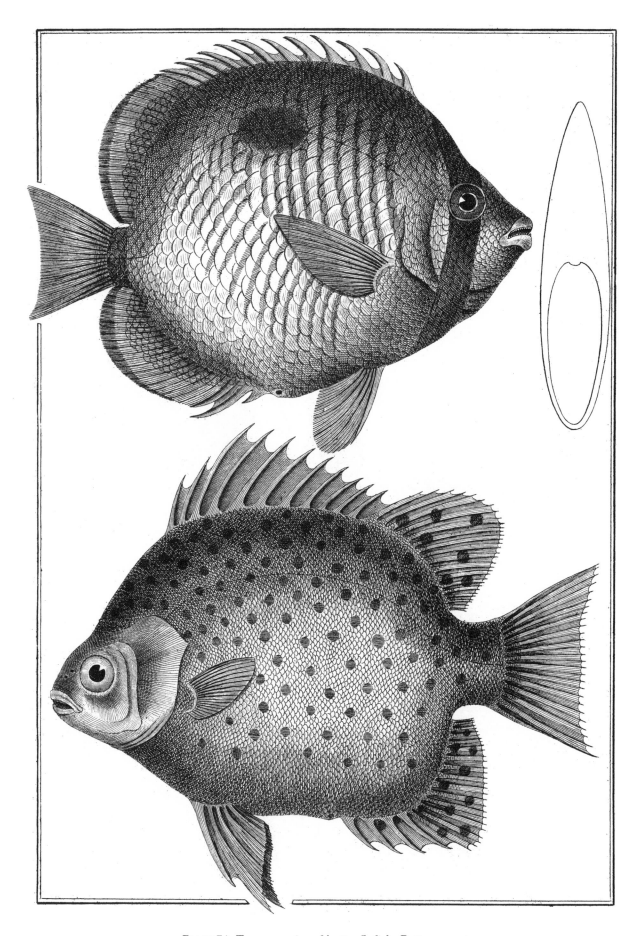

PLATE 74. Top: a species of butterflyfish. Bottom: scat.

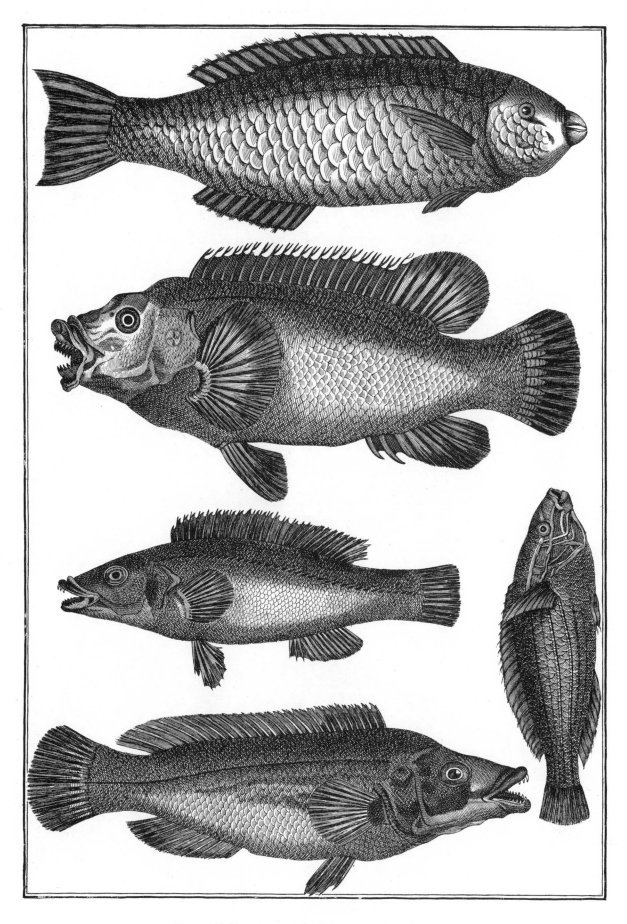

PLATE 75. Top: parrotfish. Others: species of wrasse.

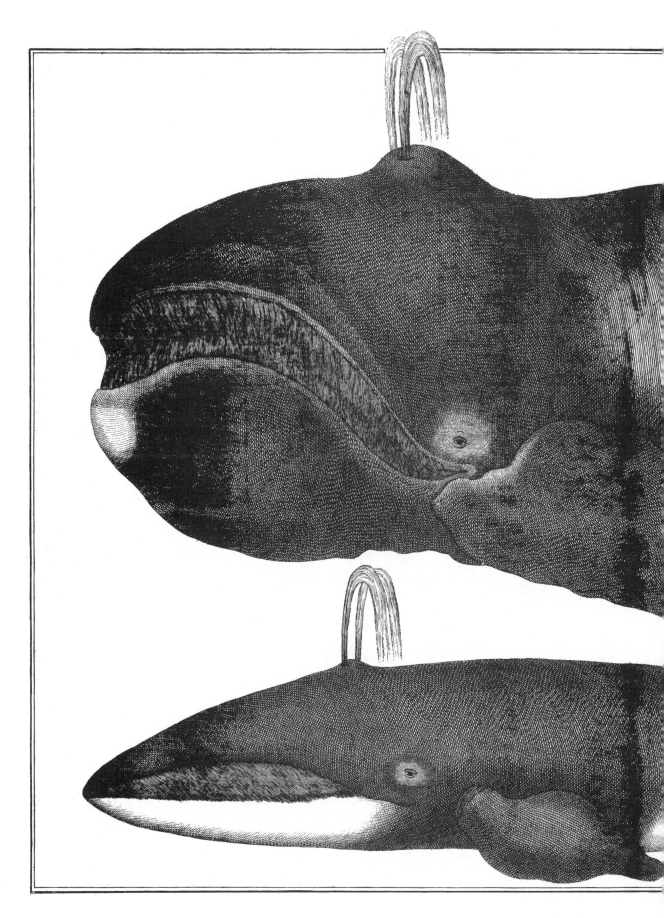

PLATE 76/77. Top: right whale. Bottom: pygmy right whale or fin whale (?).

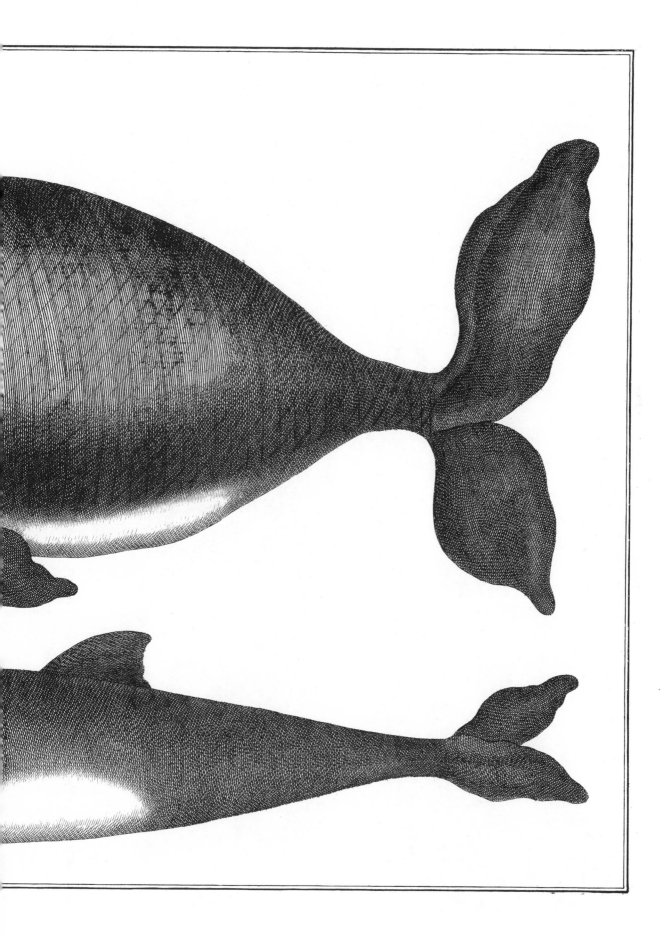

PLATE 78. Sperm whales.

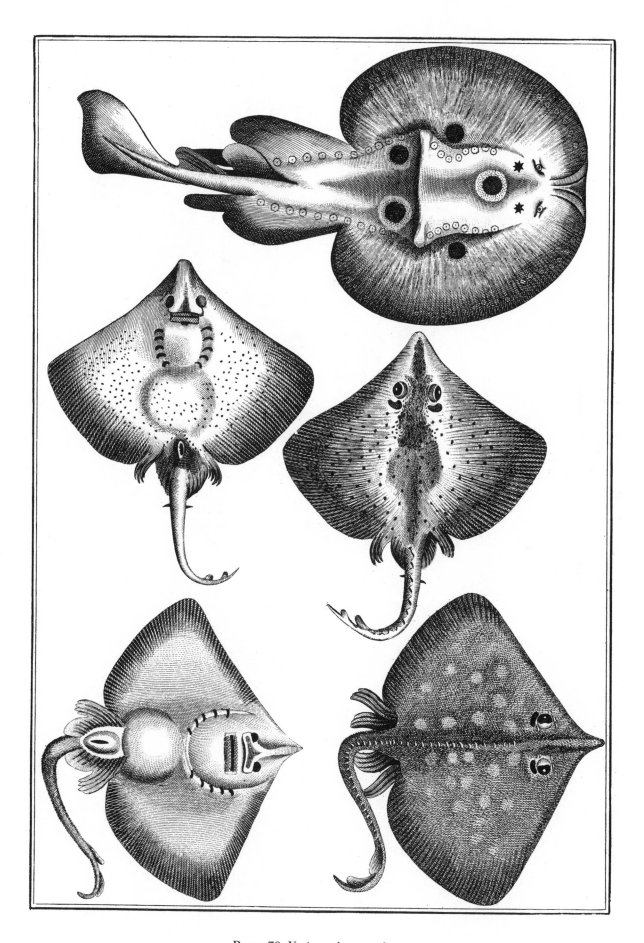

PLATE 79. Various skates and rays.

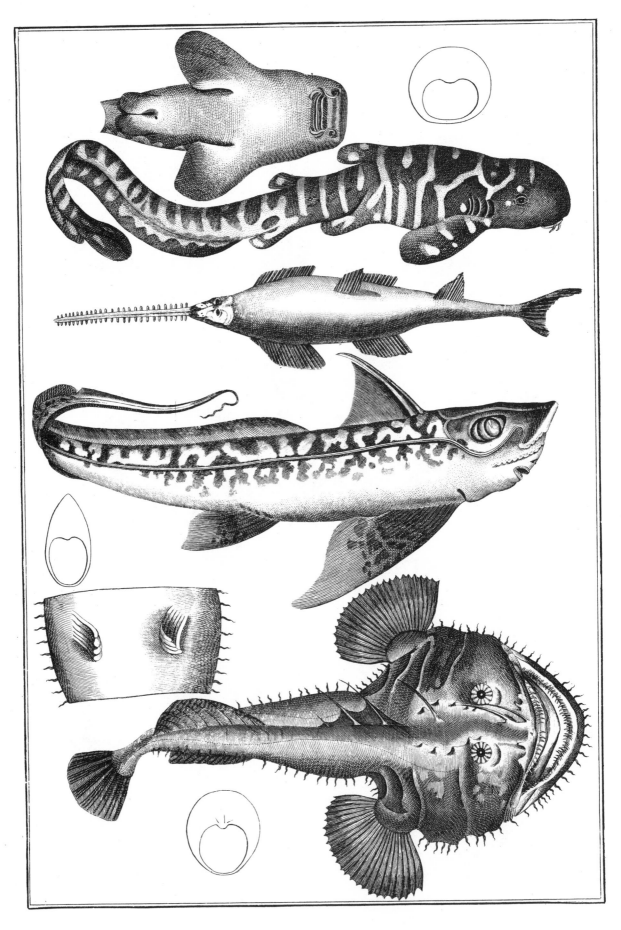

PLATE 80. Top to bottom: a species of shark; a sawfish; ?; goosefish (?).

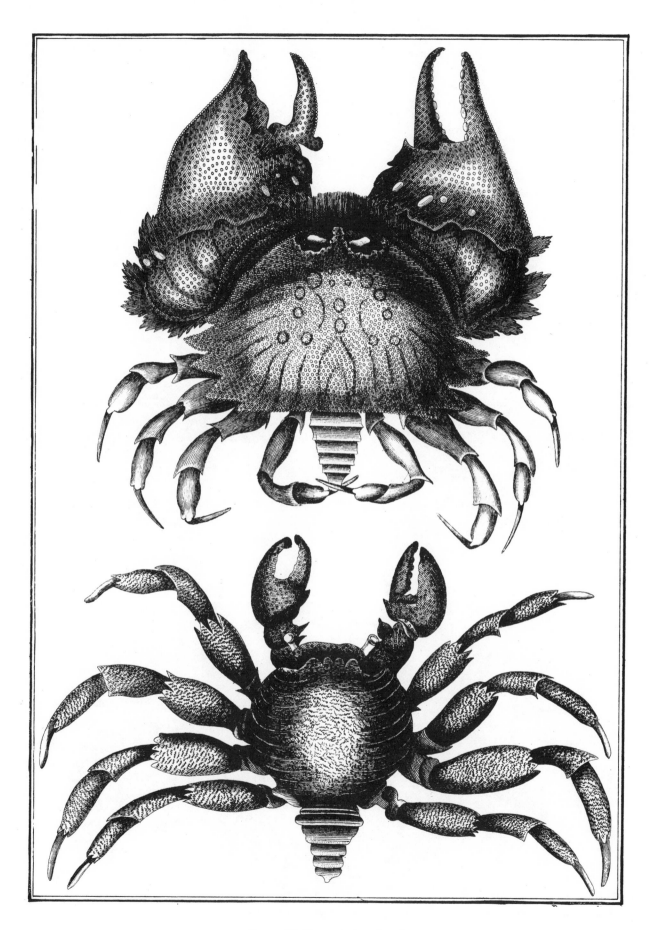

PLATE 81. Two species of crab.

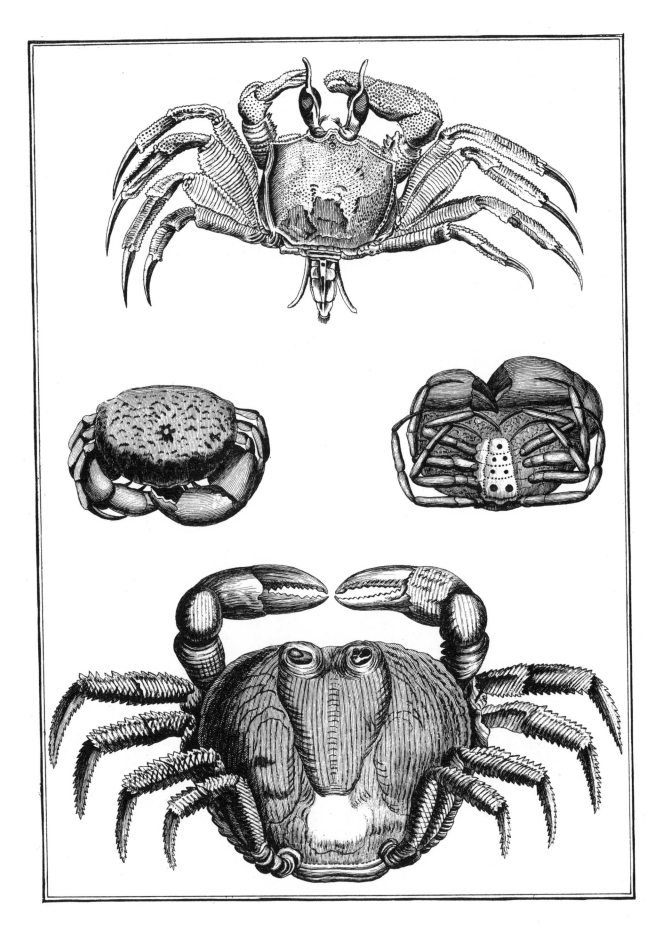

PLATE 82. Various species of crab.

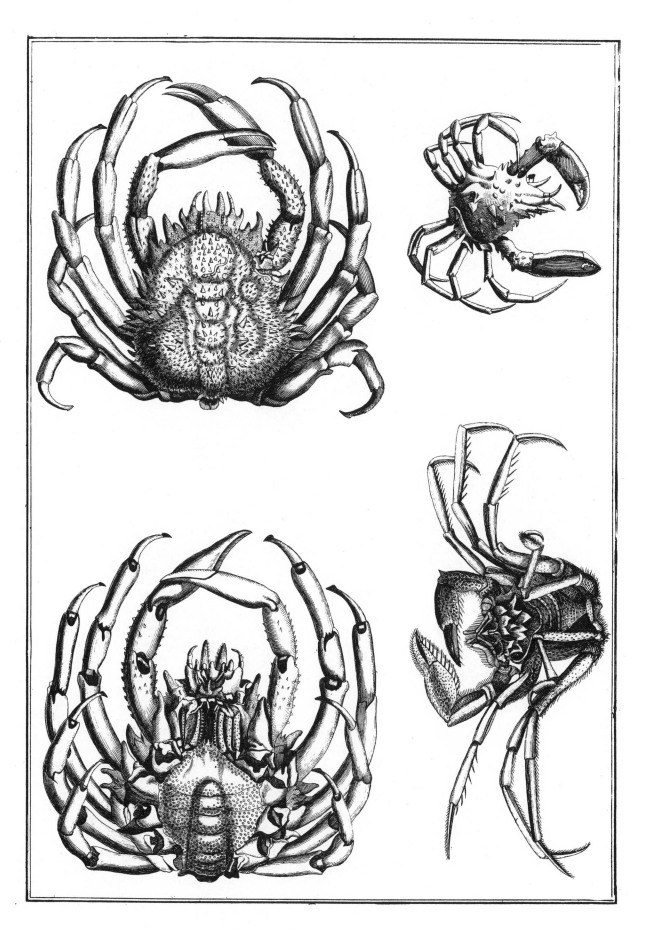

PLATE 83. Various species of crab.

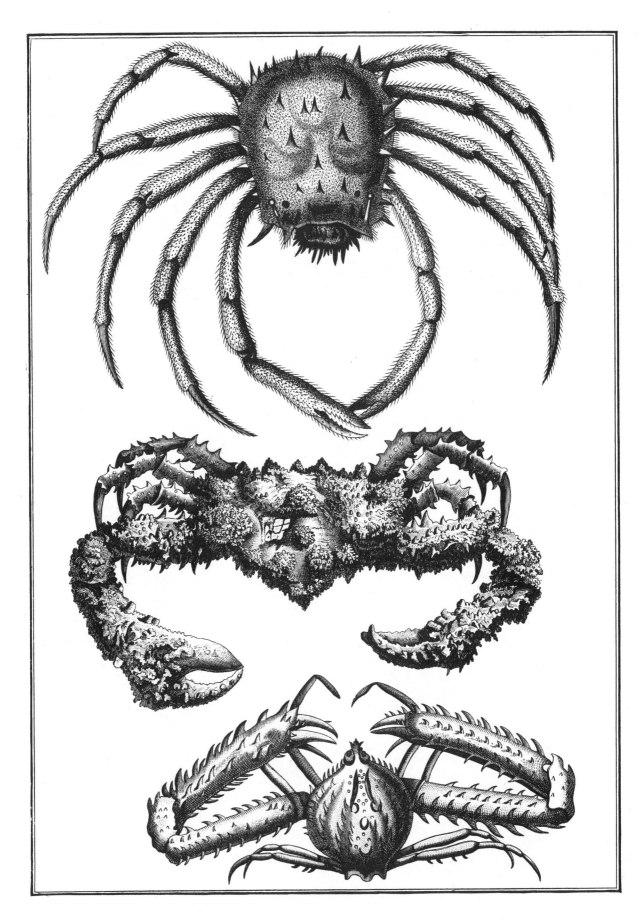

PLATE 84. Various species of crab.

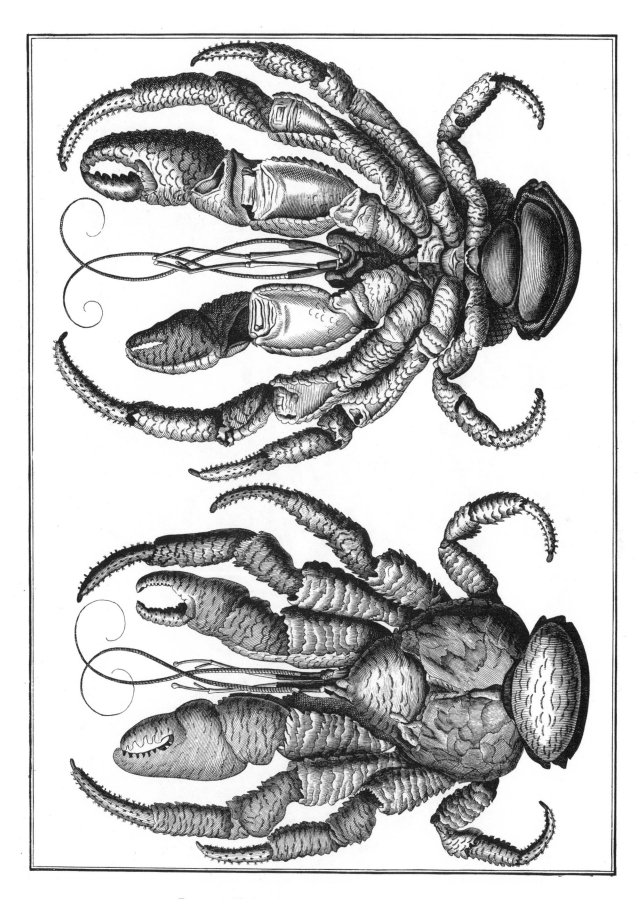

PLATE 85. Underside and top views of a species of crab.

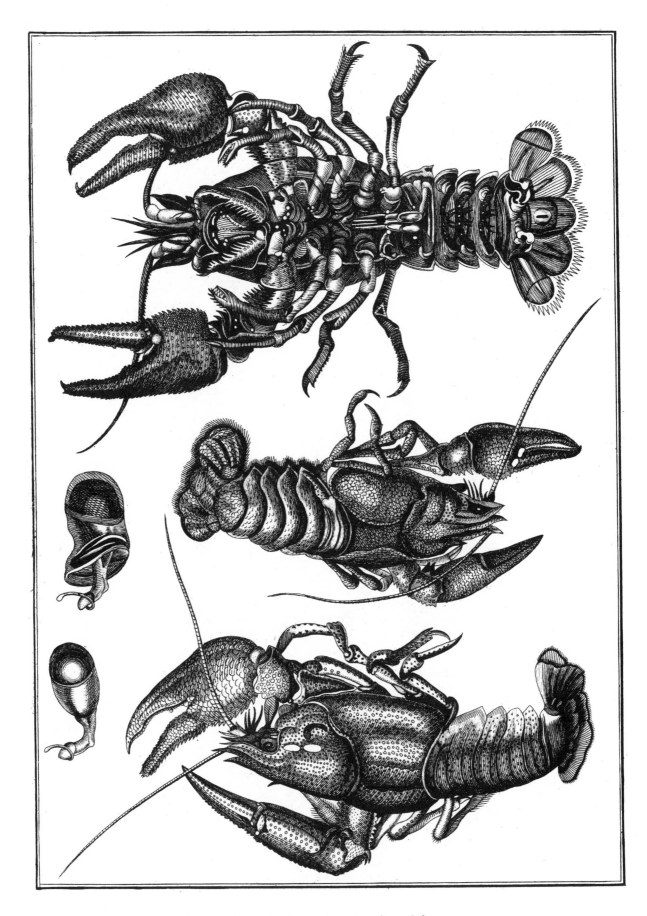

PLATE 86. Various species of crayfish.

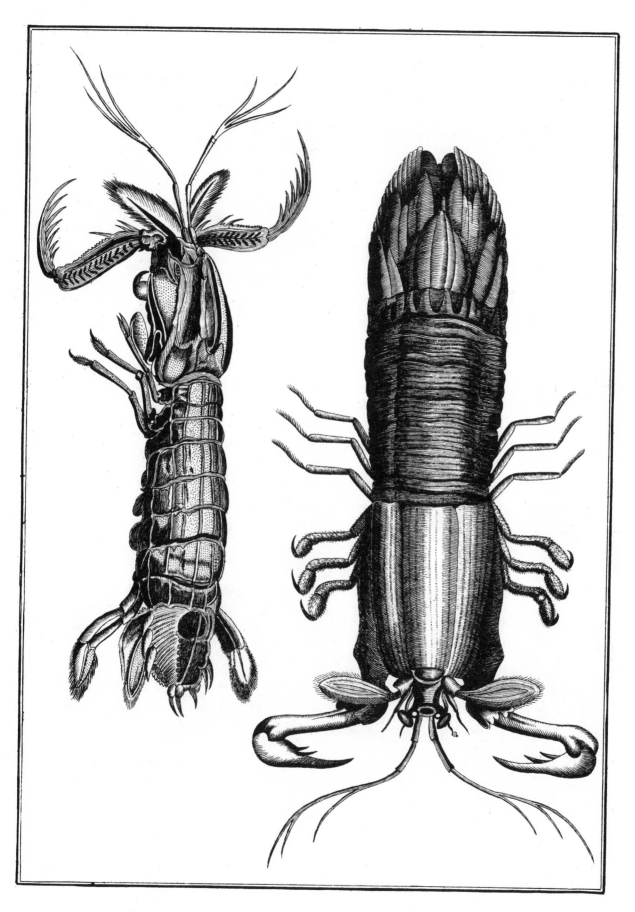

PLATE 87. Two types of (non-decapod) shrimp or related crustaceans.

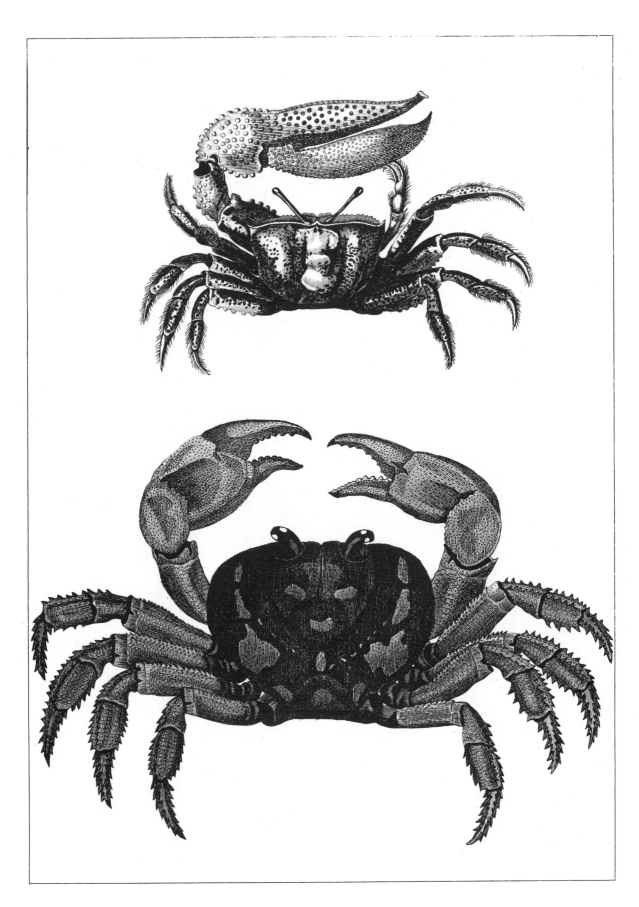

PLATE 88. Crabs (top: a species of fiddler crab).

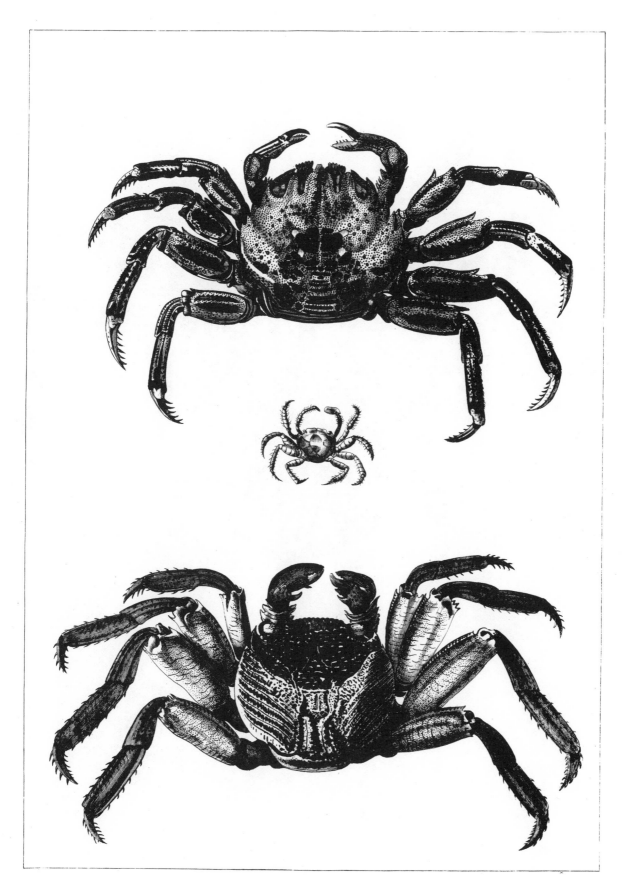

PLATE 89. Crabs.

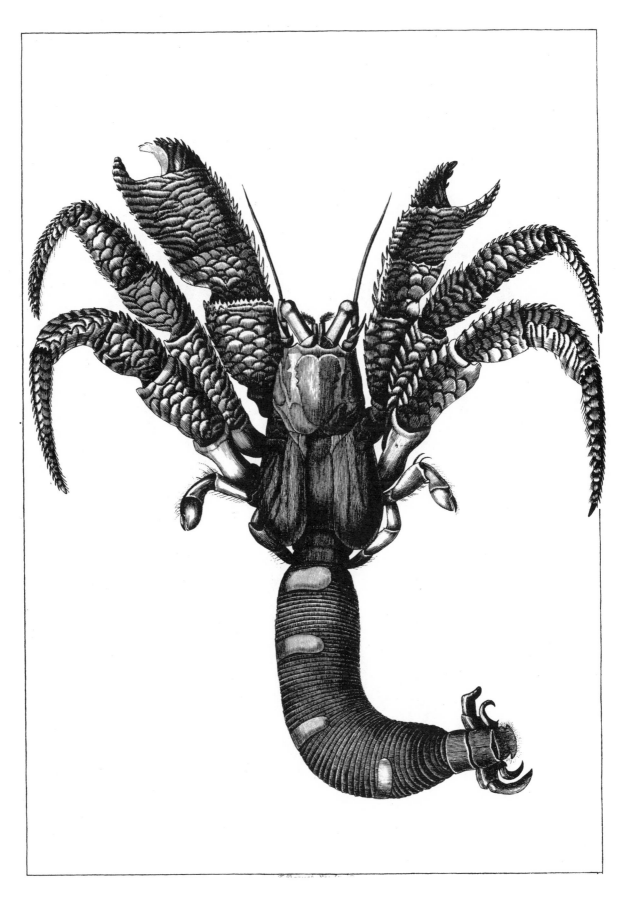

PLATE 90. A decapod crustacean.

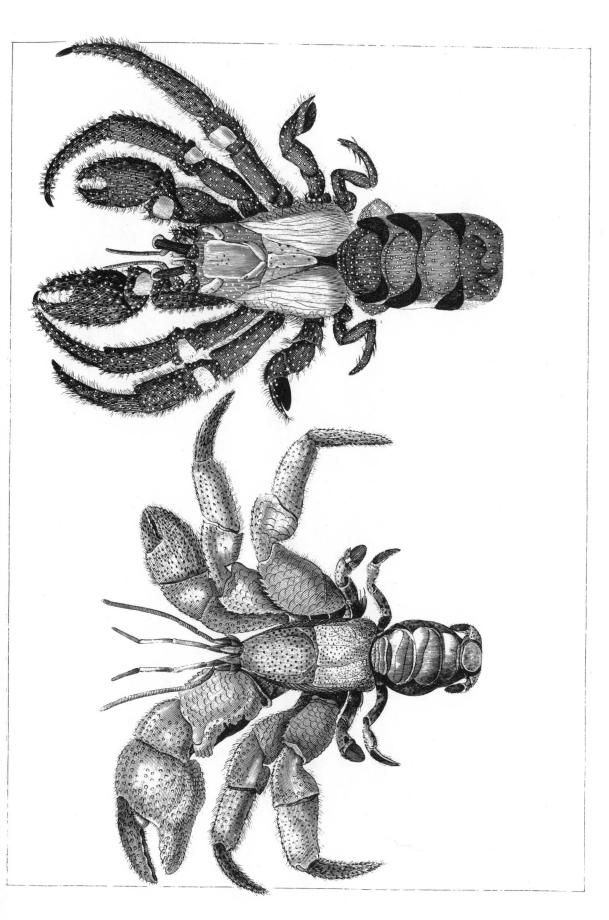

PLATE 91. Two decapod crustaceans.

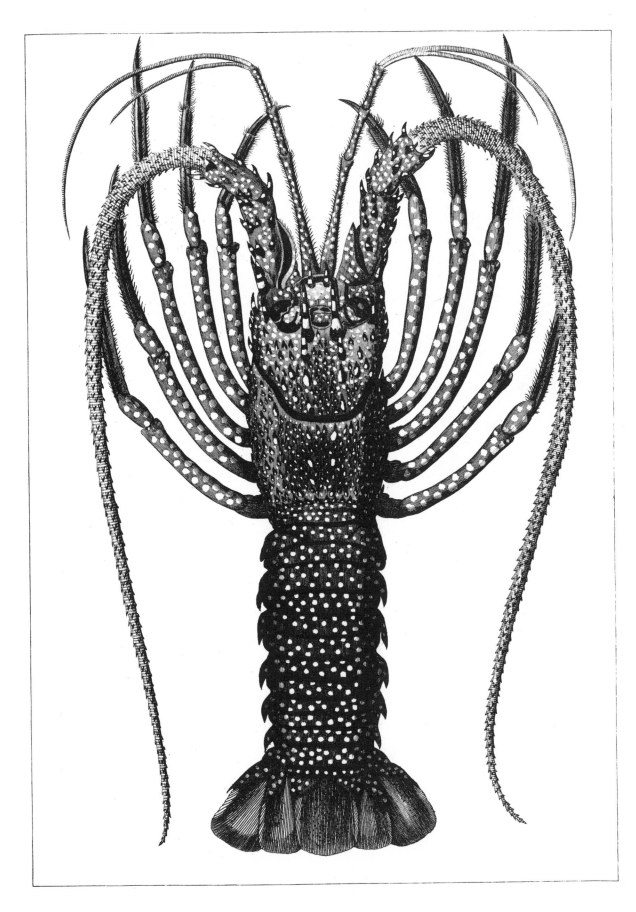

PLATE 92. A species of lobster.

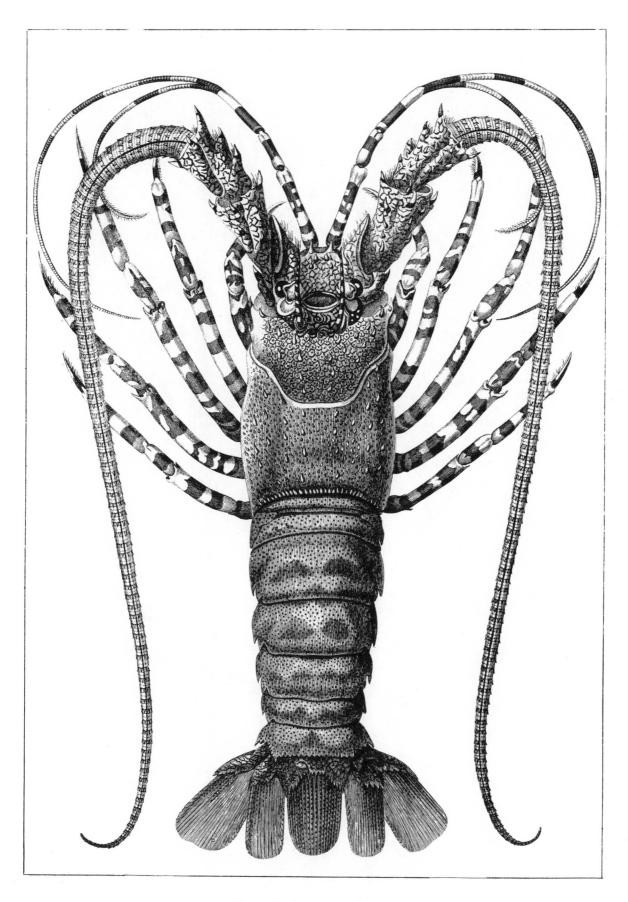

PLATE 93. A species of lobster.

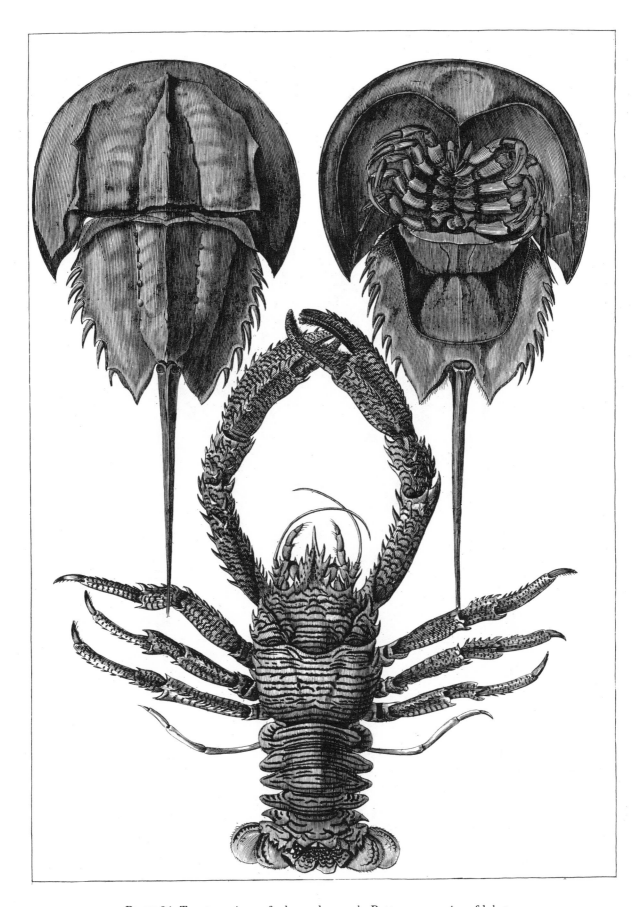

PLATE 94. Top: two views of a horseshoe crab. Bottom: a species of lobster.

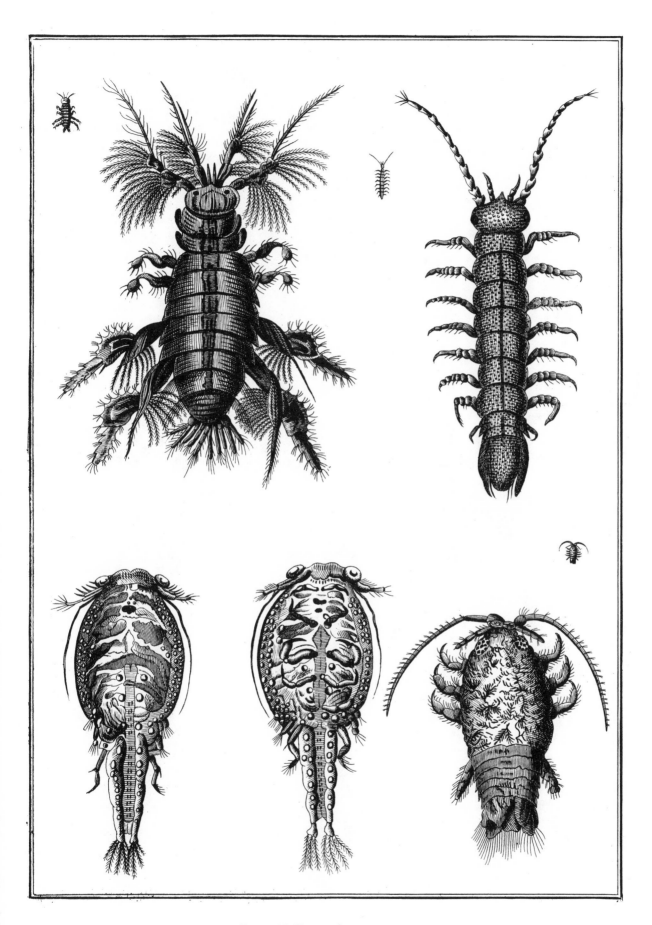

PLATE 95. Types of crustaceans.

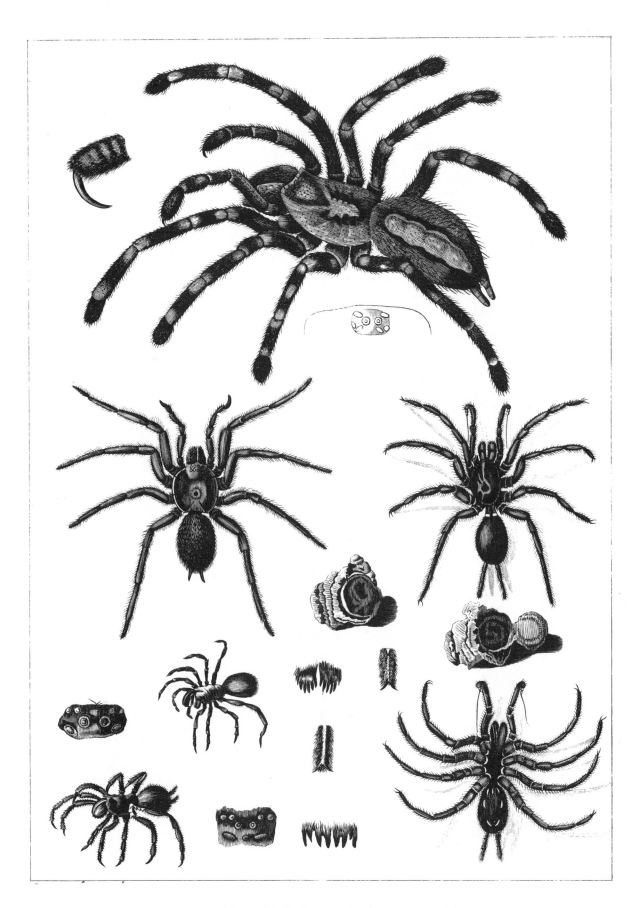

PLATE 96. Various species (top: a tarantula).

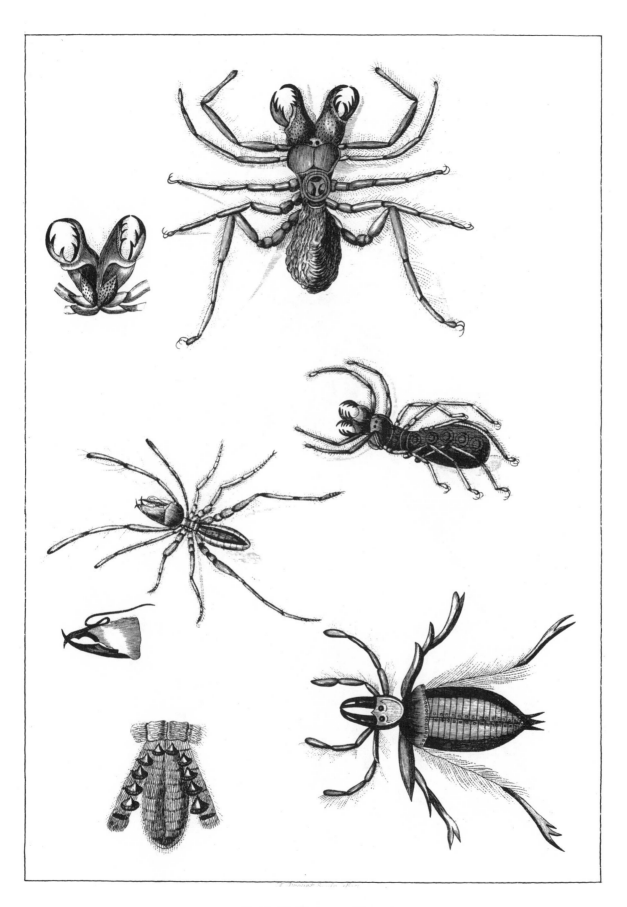

PLATE 97. Various spiders.

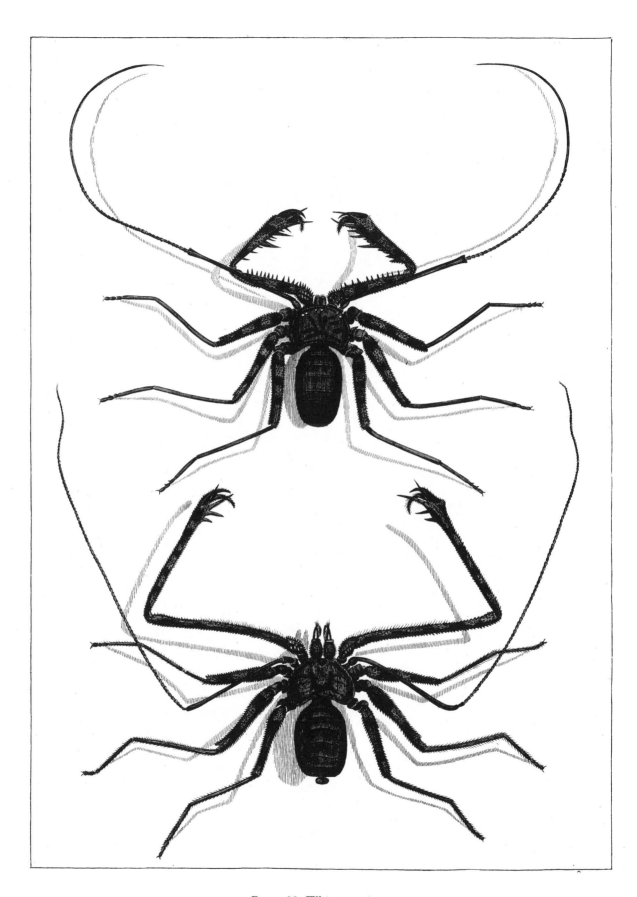

PLATE 98. Whip scorpions.

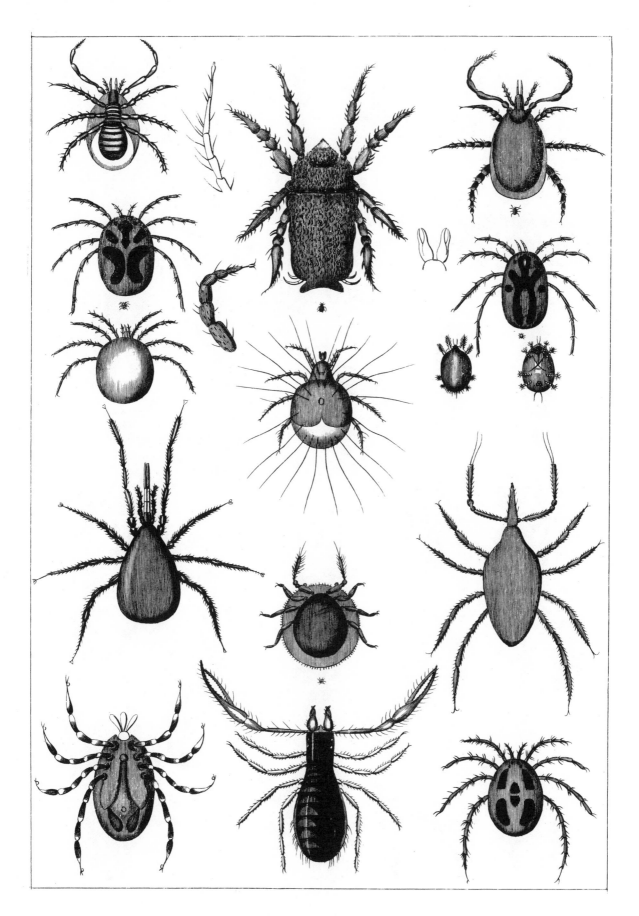

PLATE 99. Various ticks and mites.

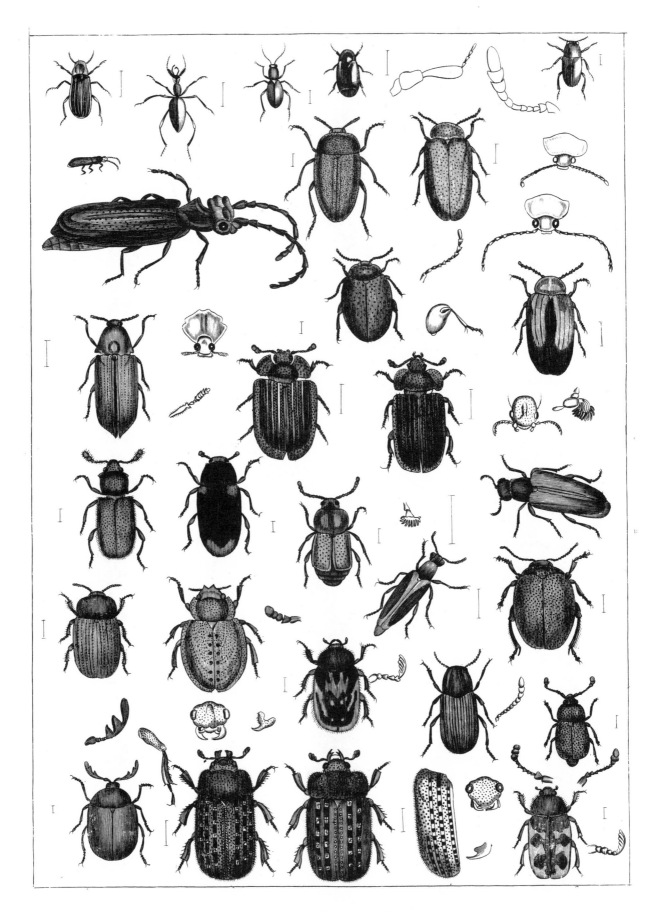

PLATE 100. Various beetles.

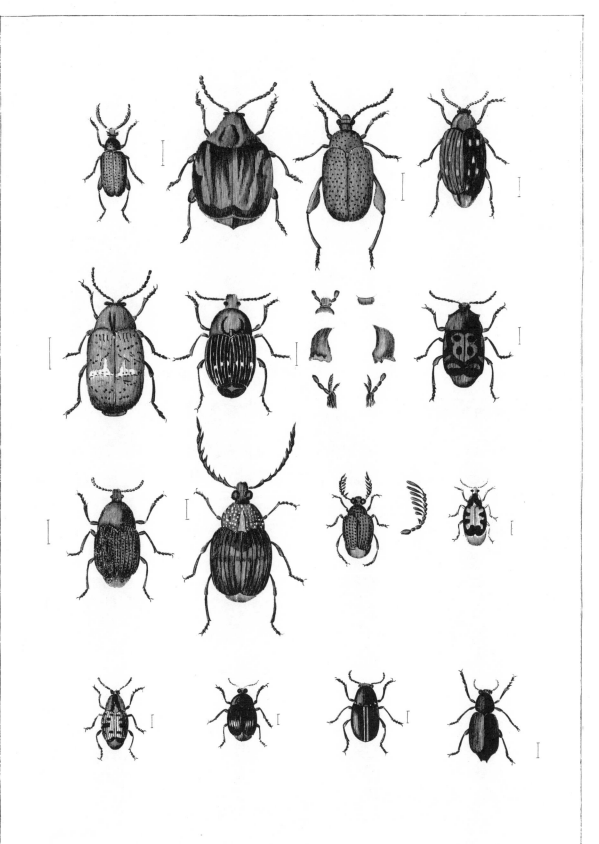

PLATE 101. Various beetles.

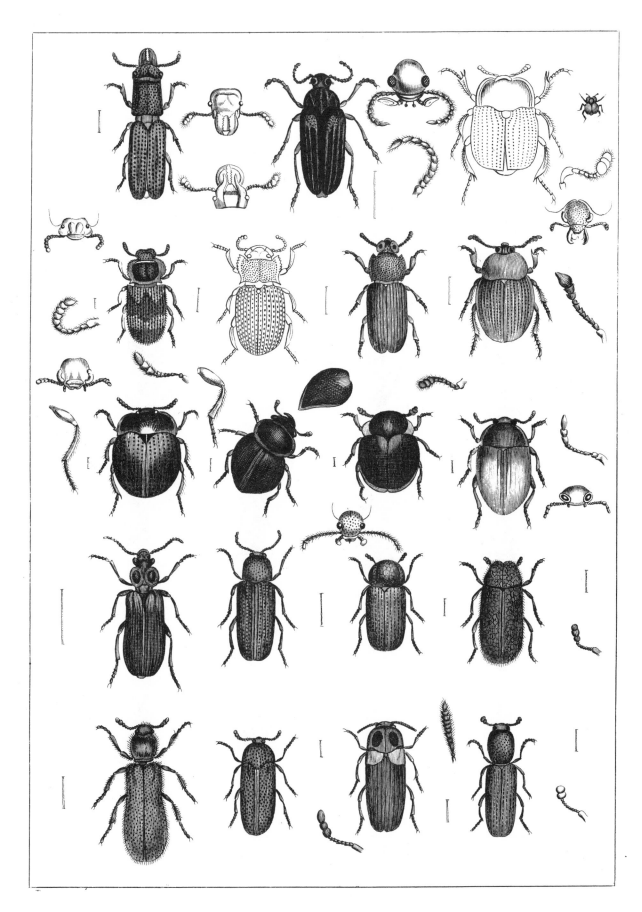

PLATE 102. Various beetles.

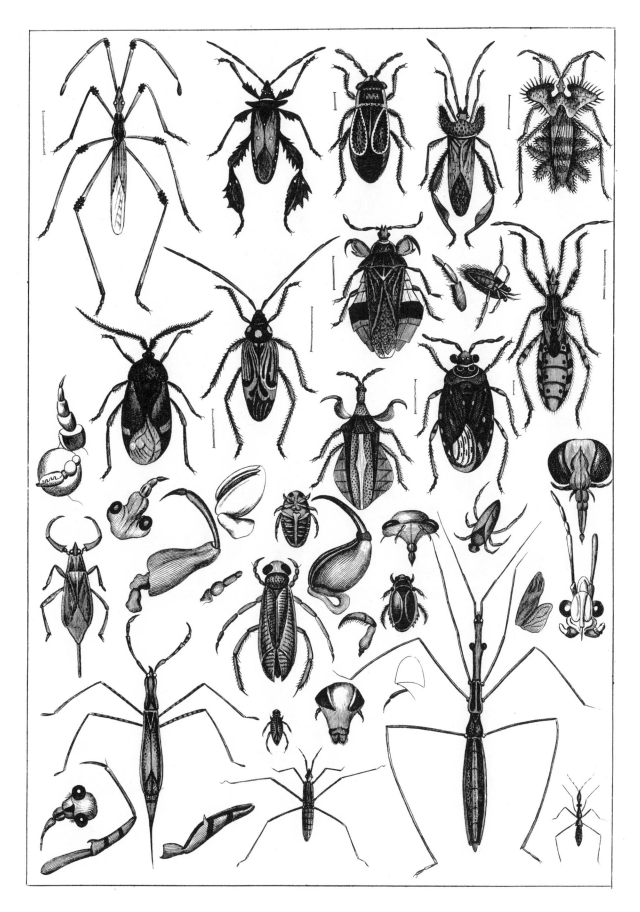

PLATE 103. Various land and water bugs.

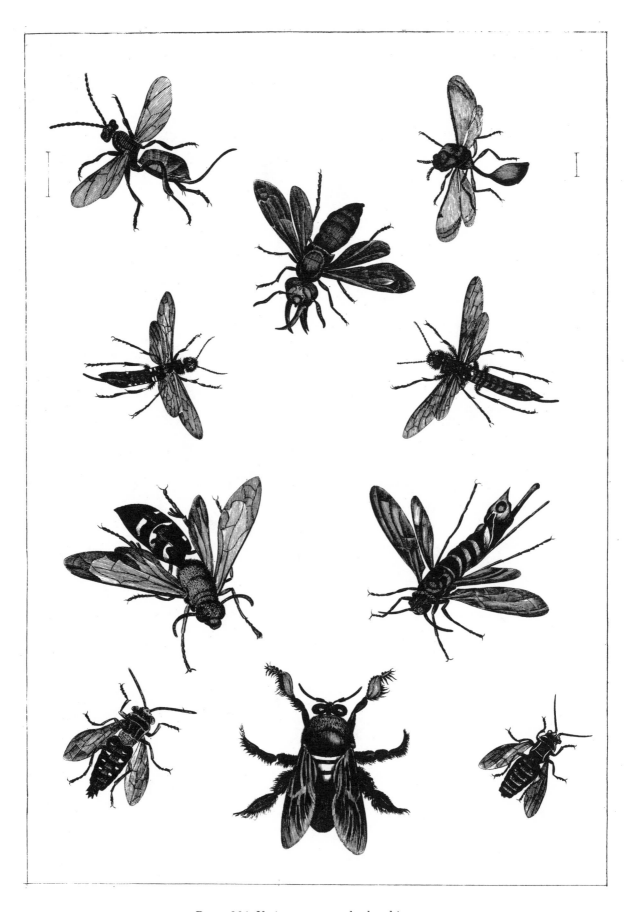

PLATE 104. Various wasps and related insects.

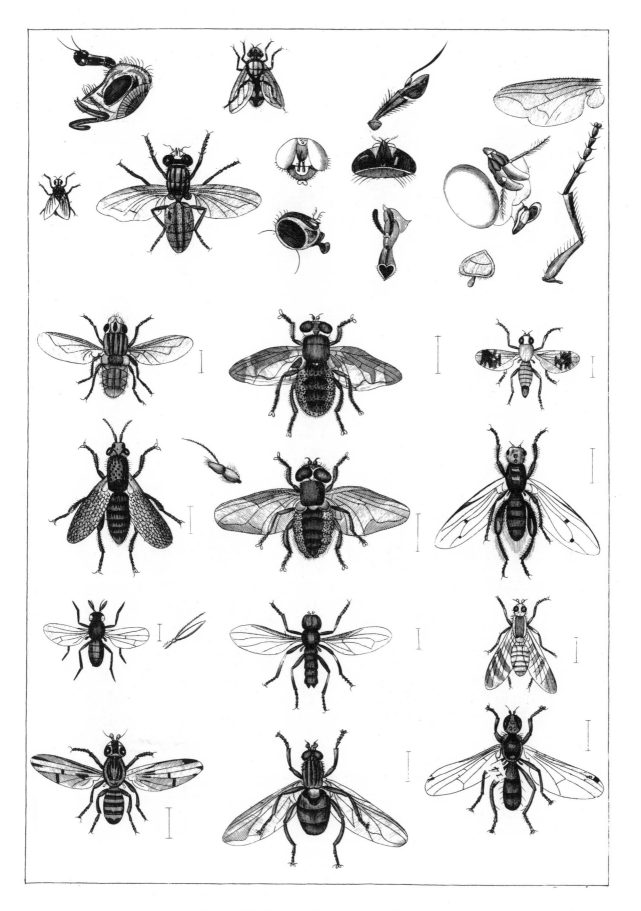

PLATE 105. Various flies and related insects.

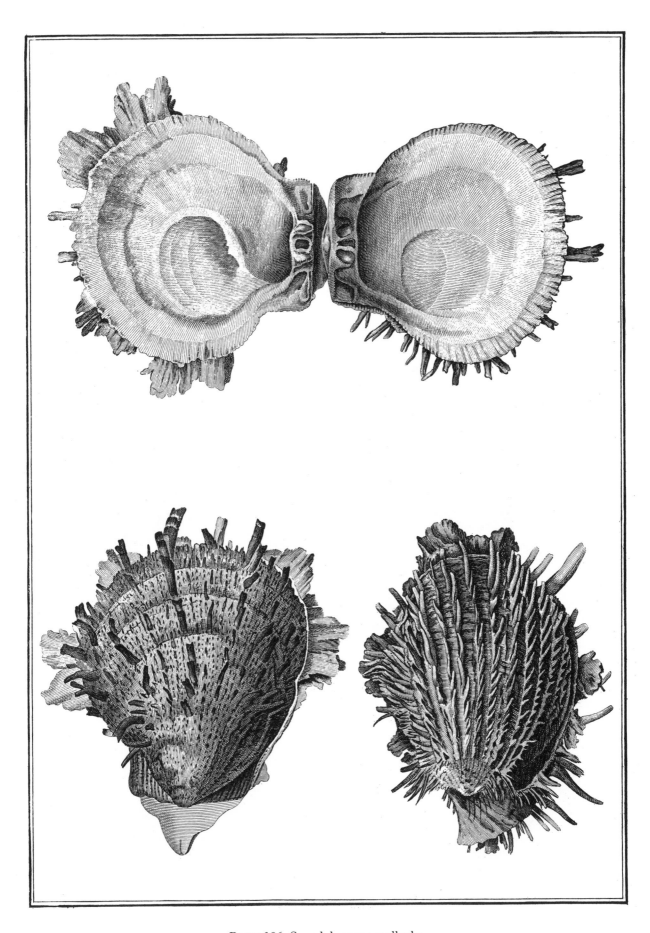

PLATE 106. Spondylus-type mollusks.

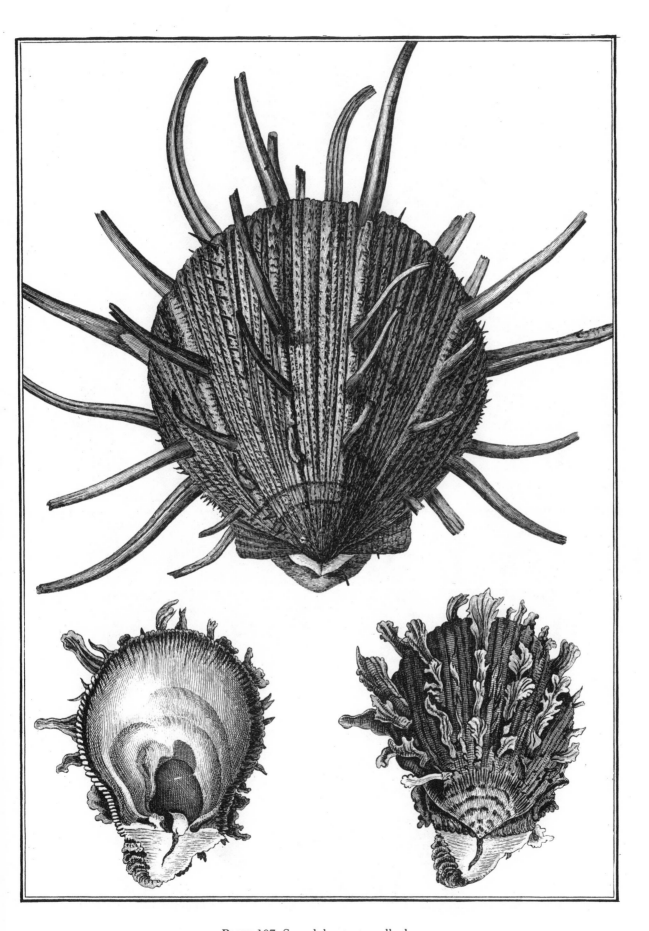

PLATE 107. Spondylus-type mollusks.

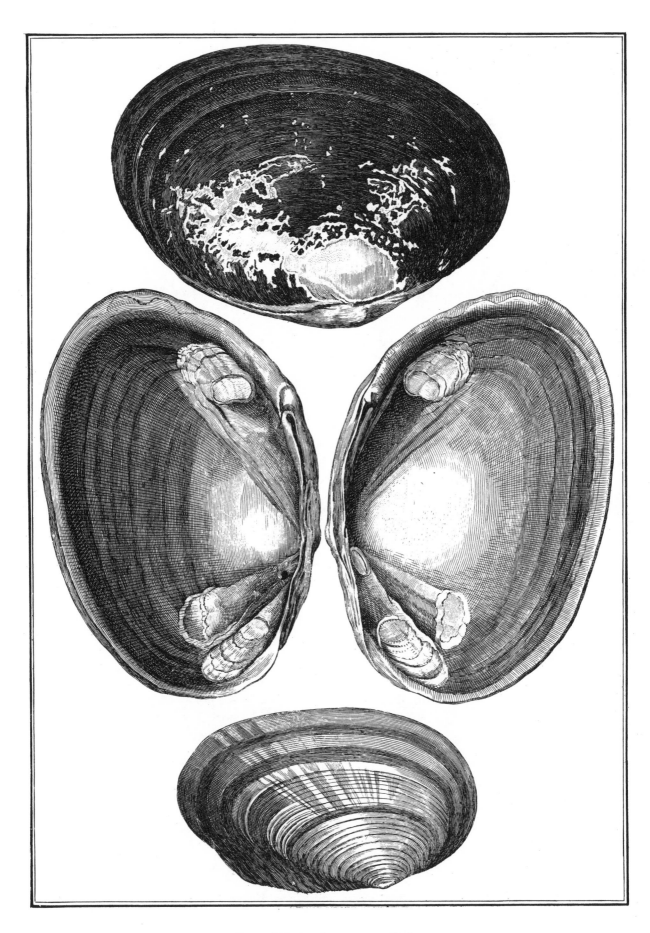

PLATE 108. Anodont-type mollusks.

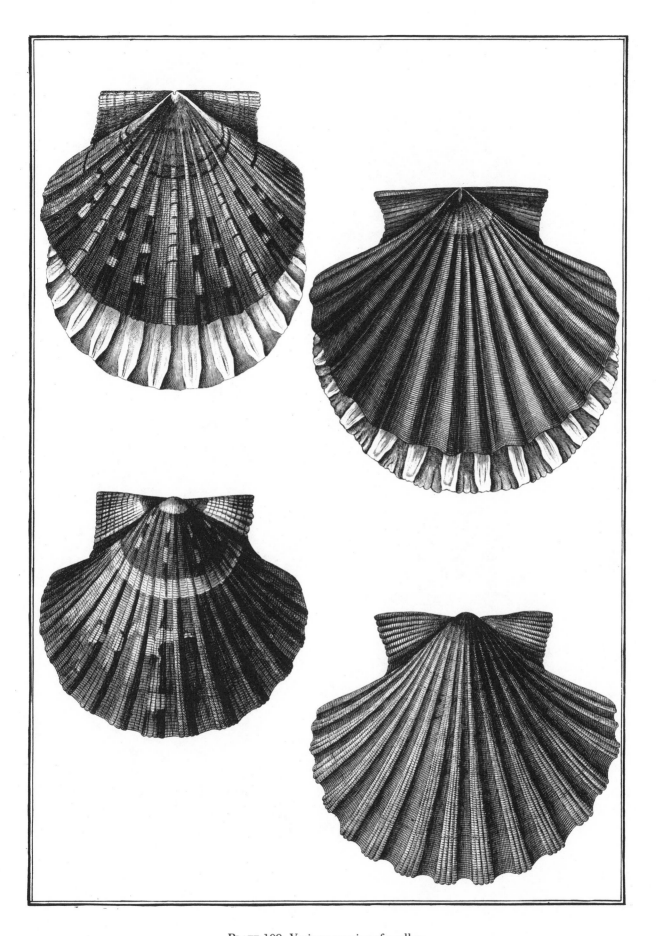

PLATE 109. Various species of scallop.

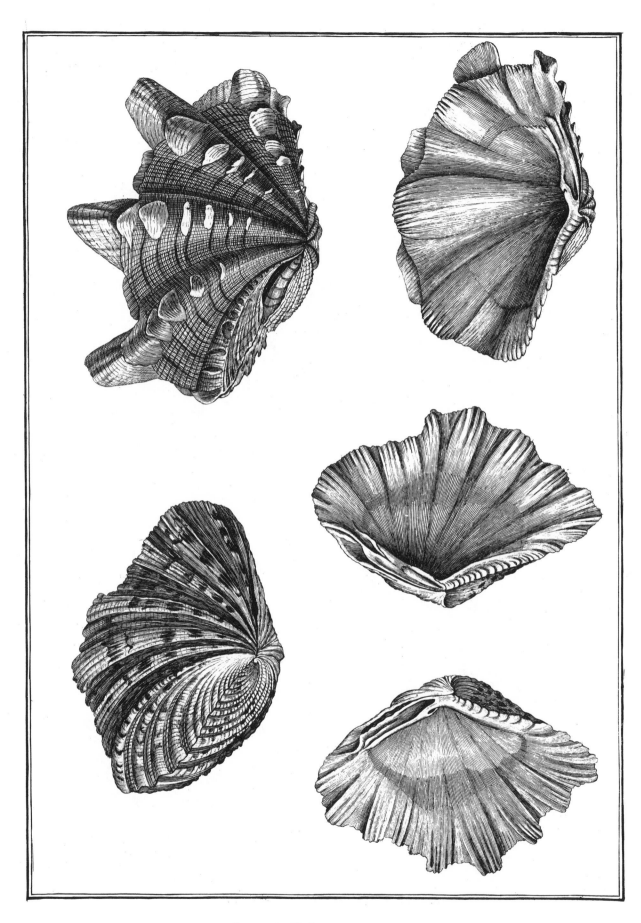

PLATE 110. Tridacna-type mollusks.

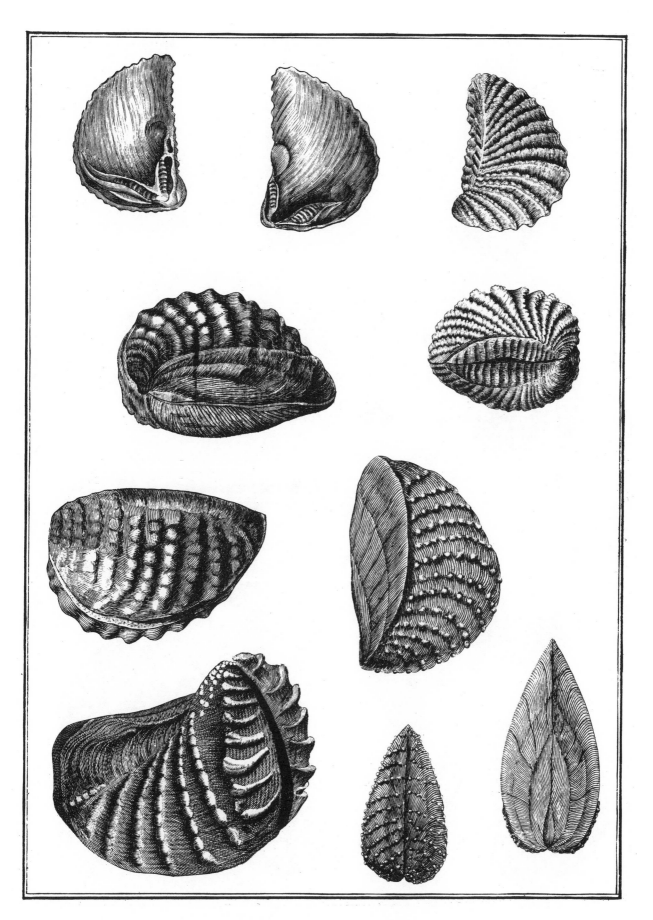

PLATE 111. Trigonia-type mollusks.

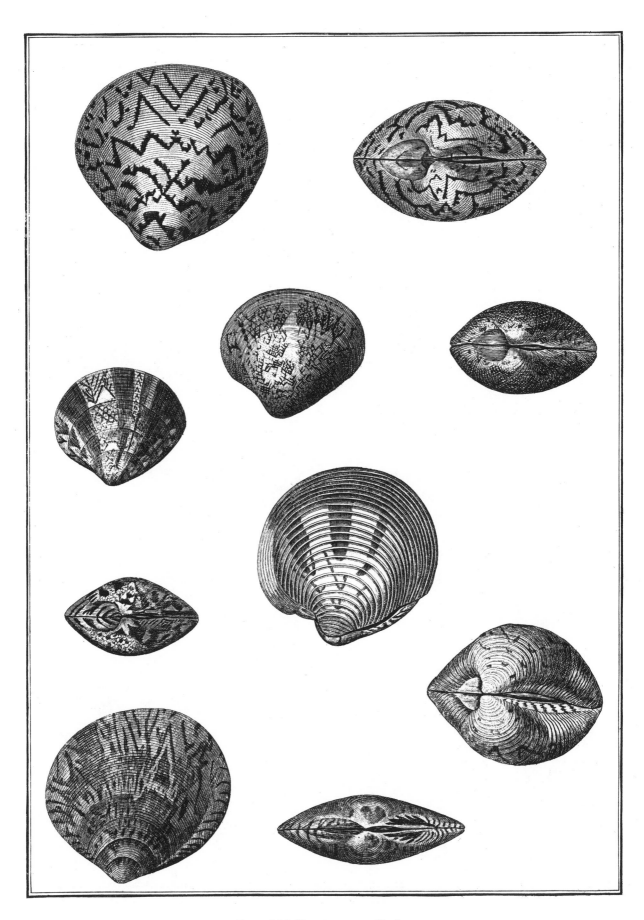

PLATE 112. Venus-type mollusks.

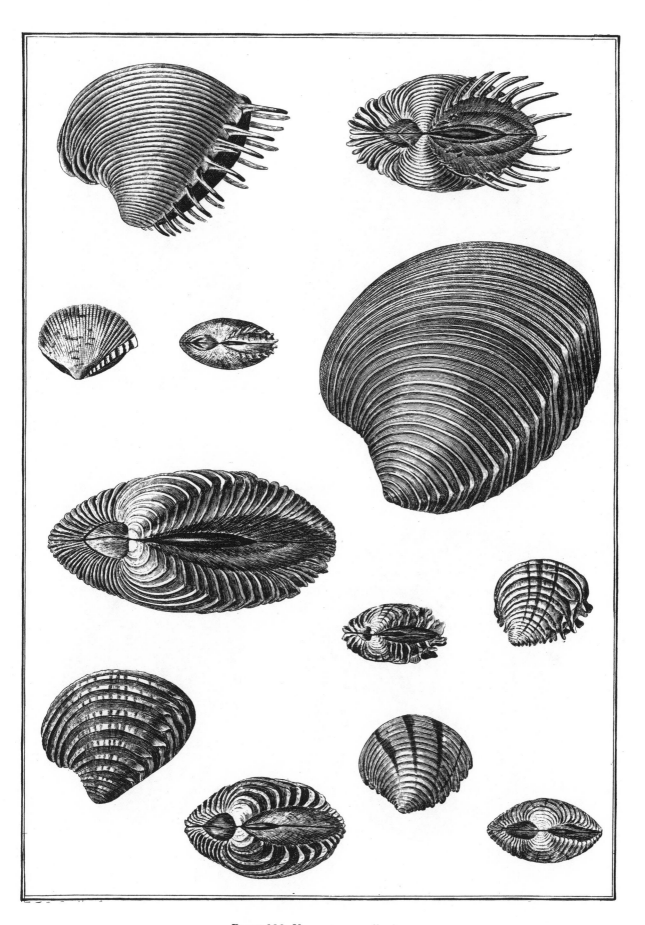

PLATE 113. Venus-type mollusks.

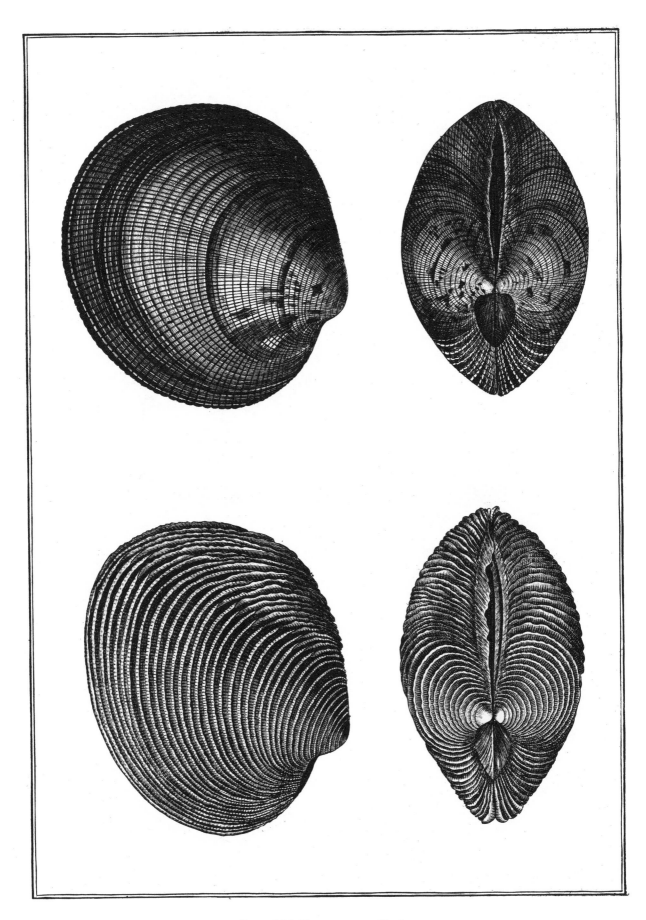

PLATE 114. Venus-type mollusks.

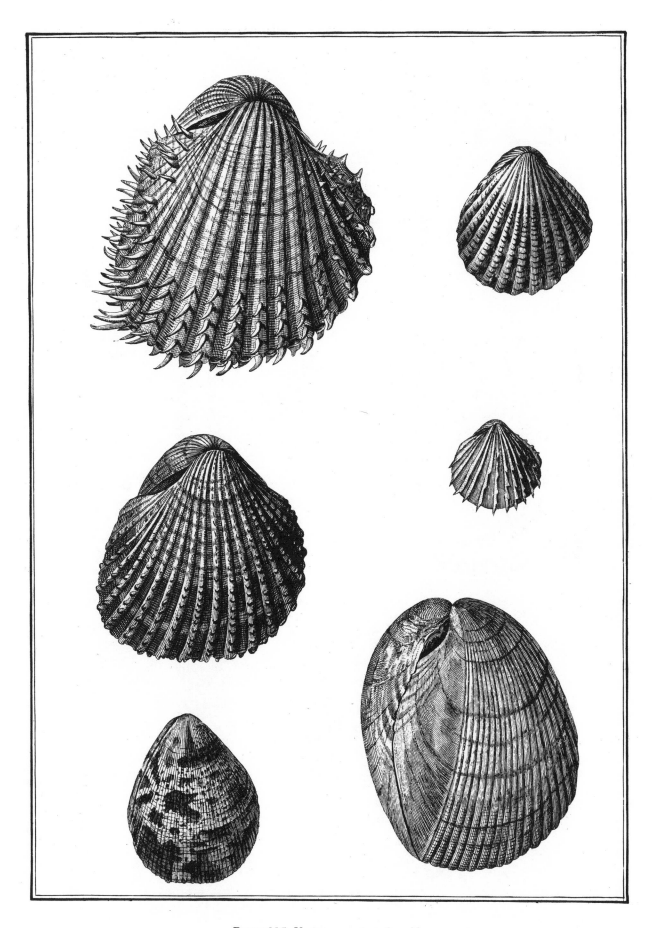

PLATE 115. Various species of cockle.

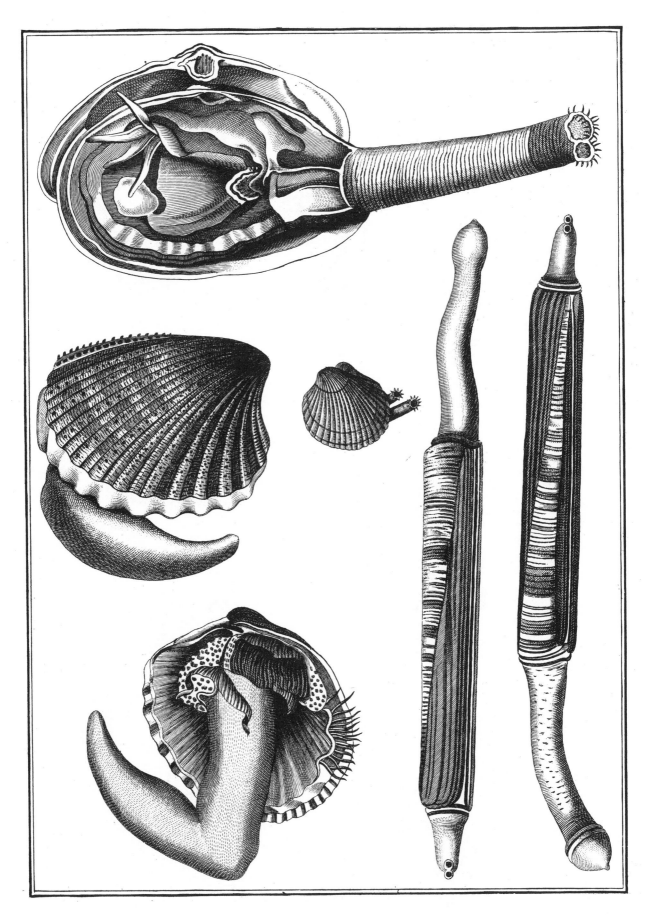

PLATE 116. Anatomical studies of bivalve mollusks.

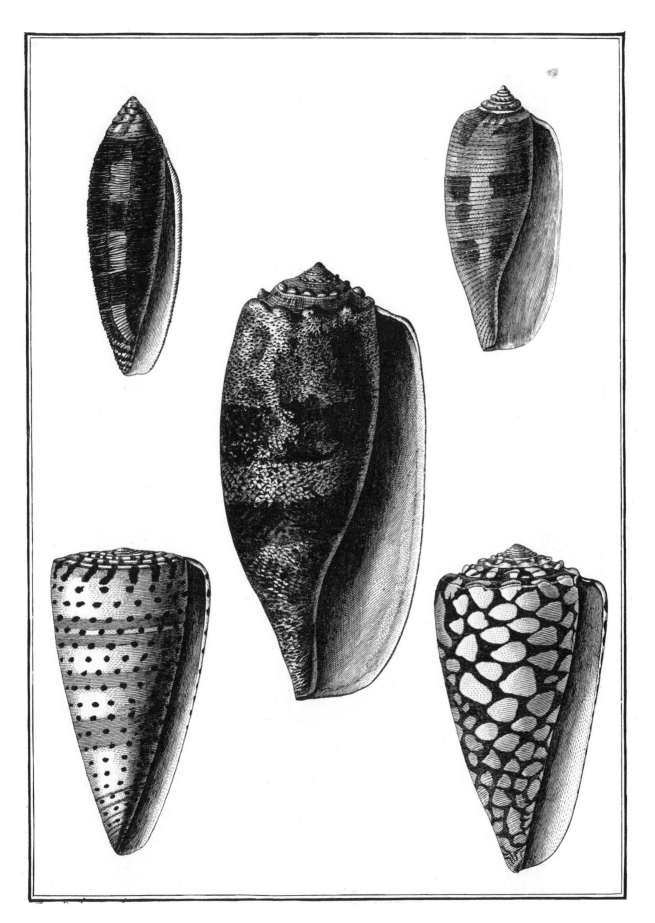

PLATE 117. Various species of cone shells.

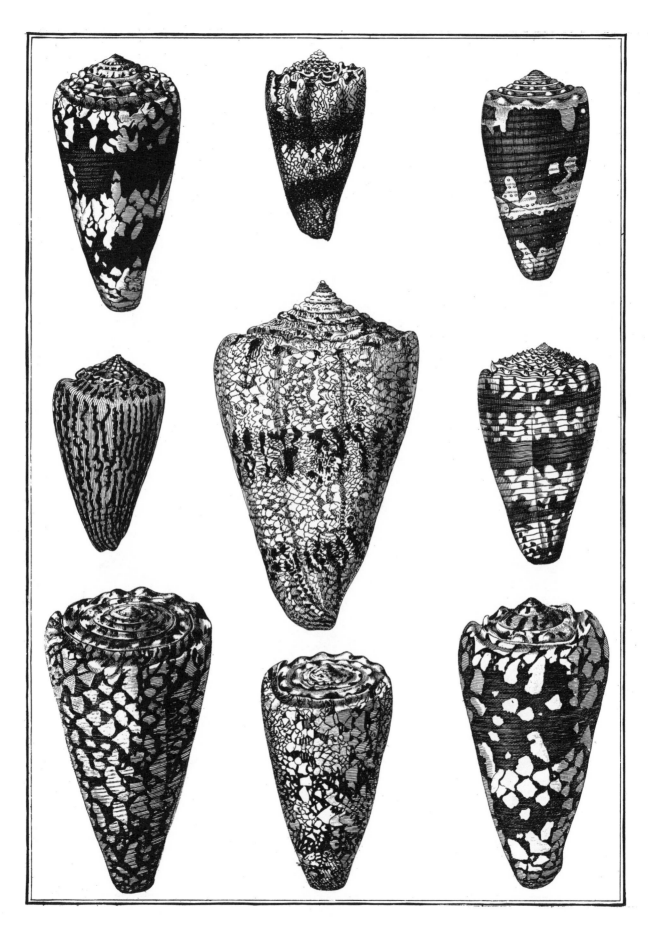

PLATE 118. Various species of cone shells.

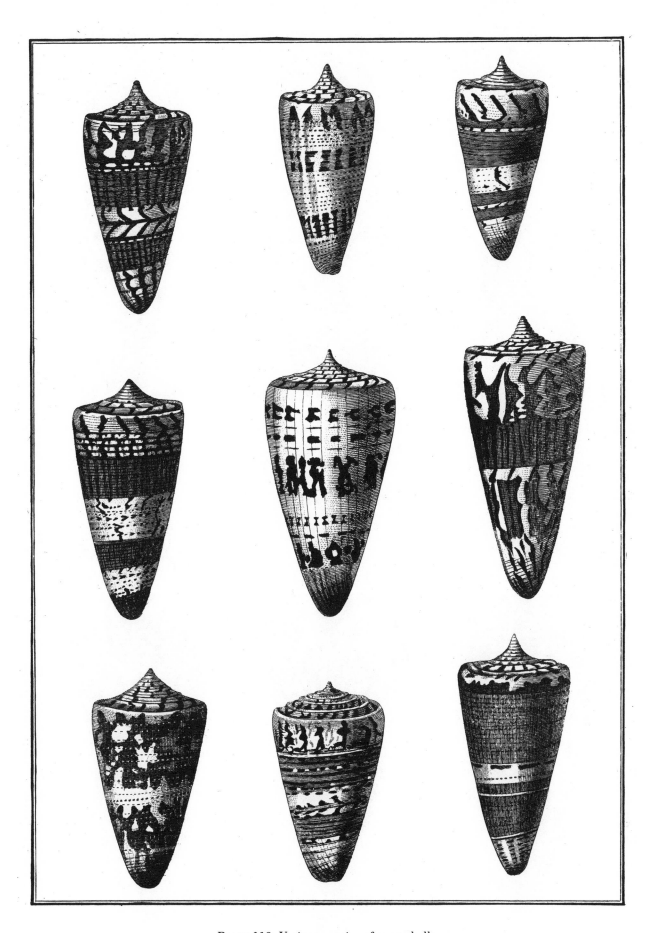

PLATE 119. Various species of cone shells.

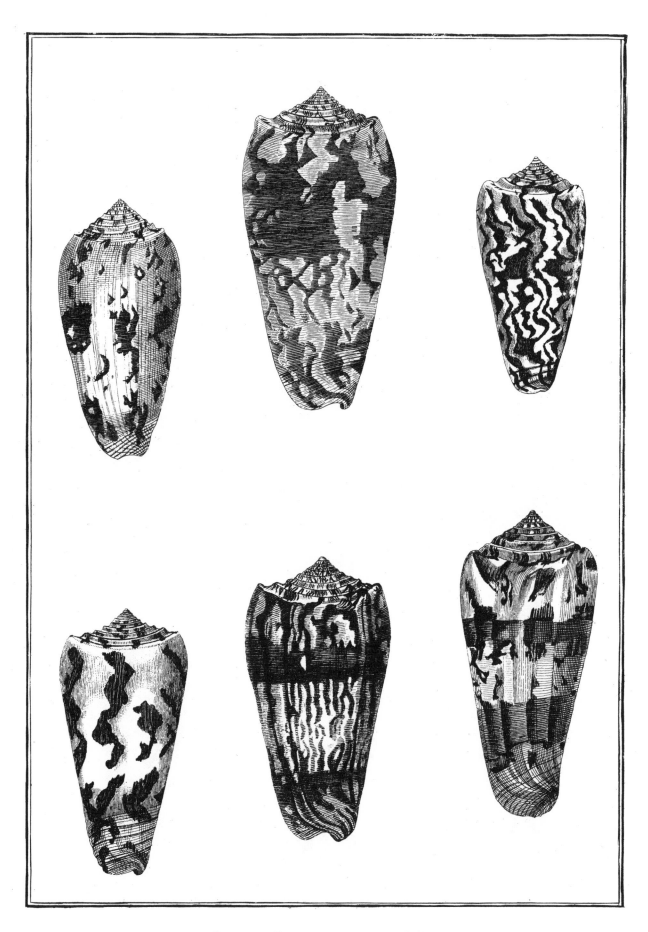

PLATE 120. Various species of cone shells.

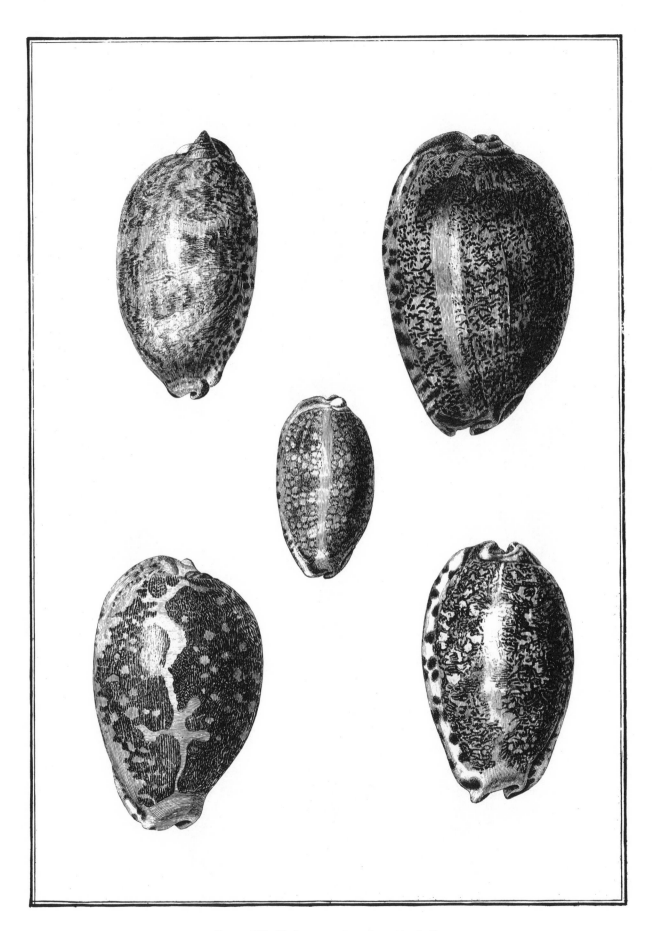

PLATE 121. Various species of cowrie shells.

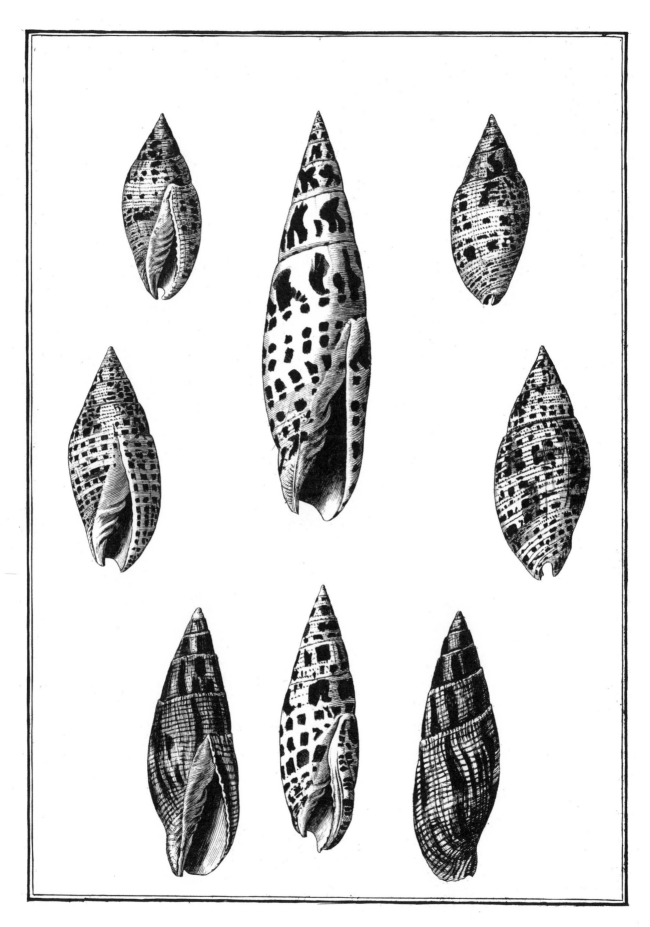

PLATE 122. Various species of miter shells.

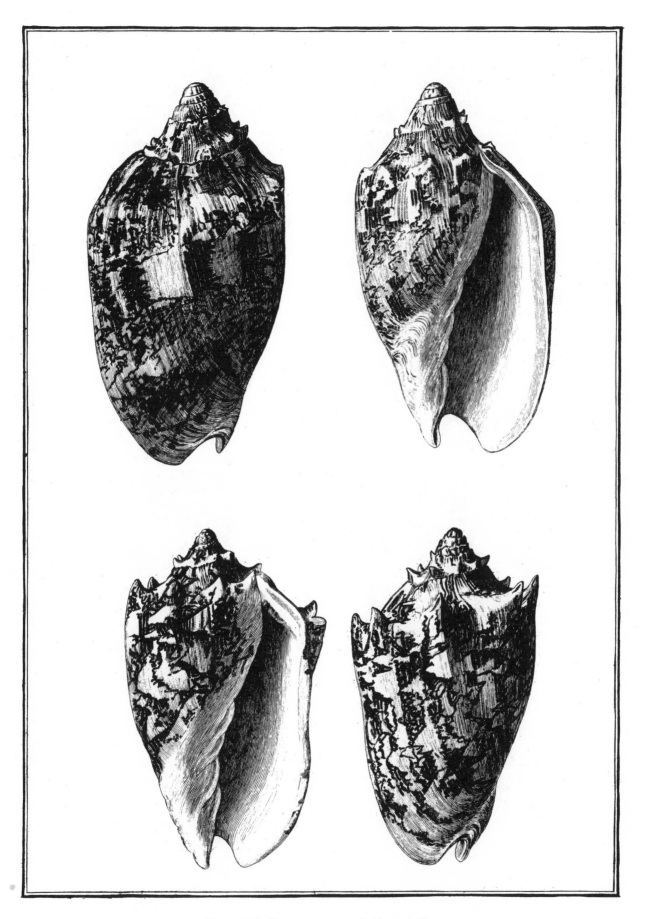

PLATE 123. Various species of volute shells.

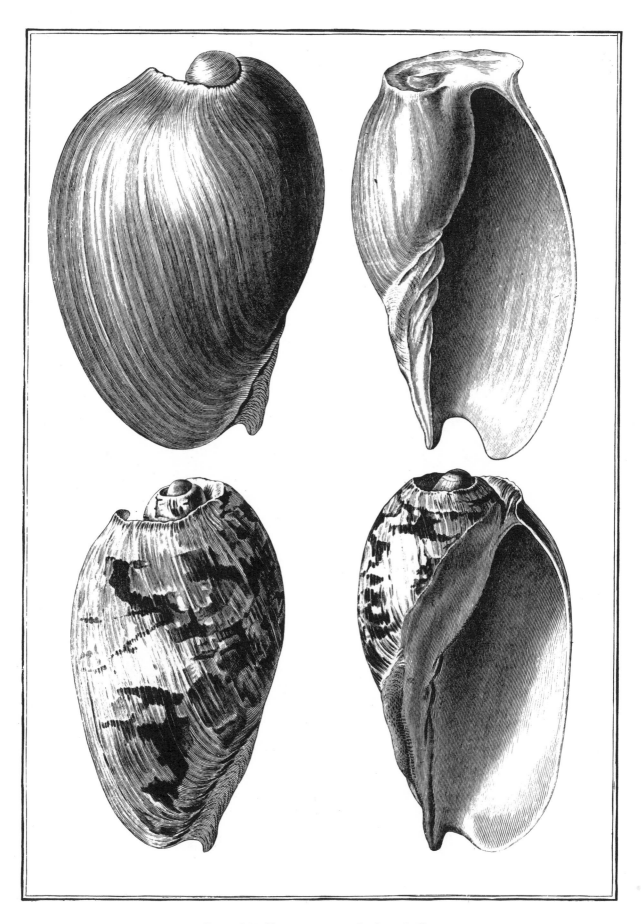

PLATE 124. Various species of volute shells.

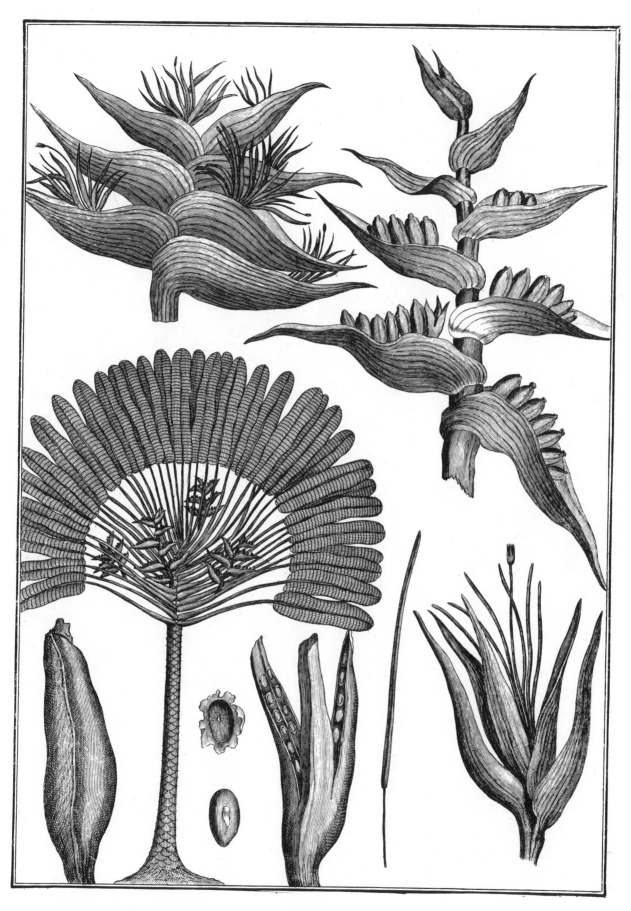

PLATE 125. Growth patterns of the traveler's-tree.

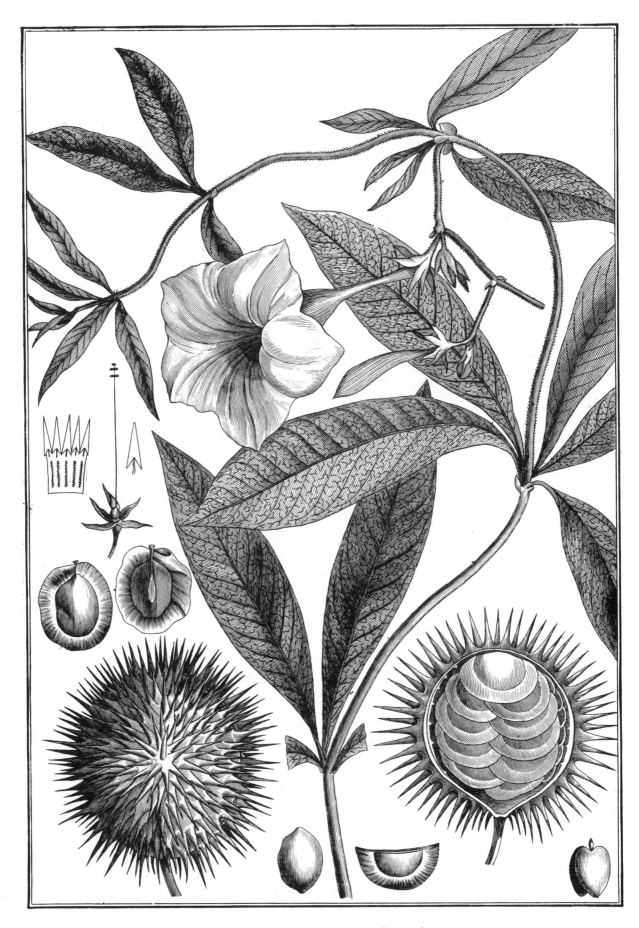

PLATE 126. Growth patterns of the allamande vine.

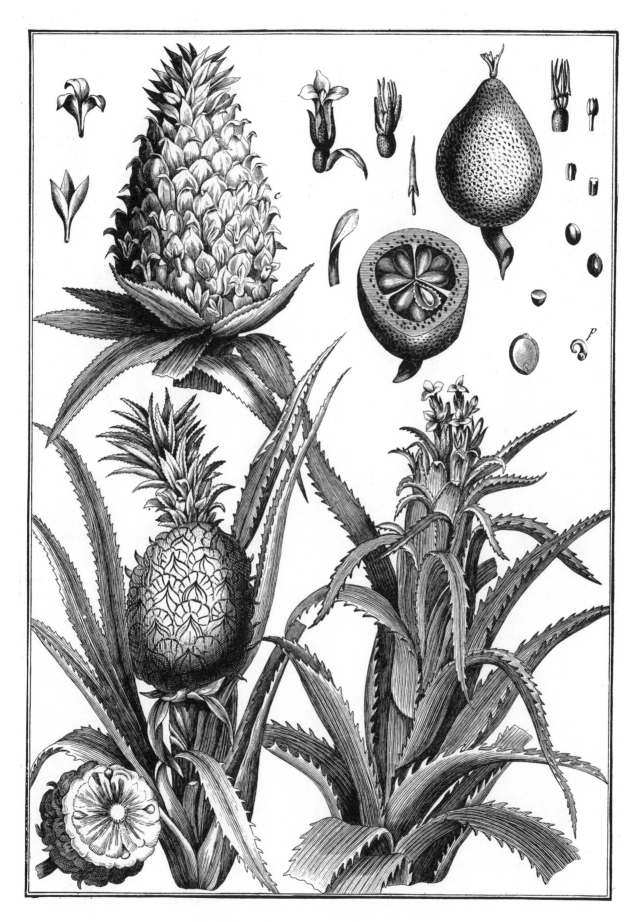

PLATE 127. Growth patterns of the pineapple.

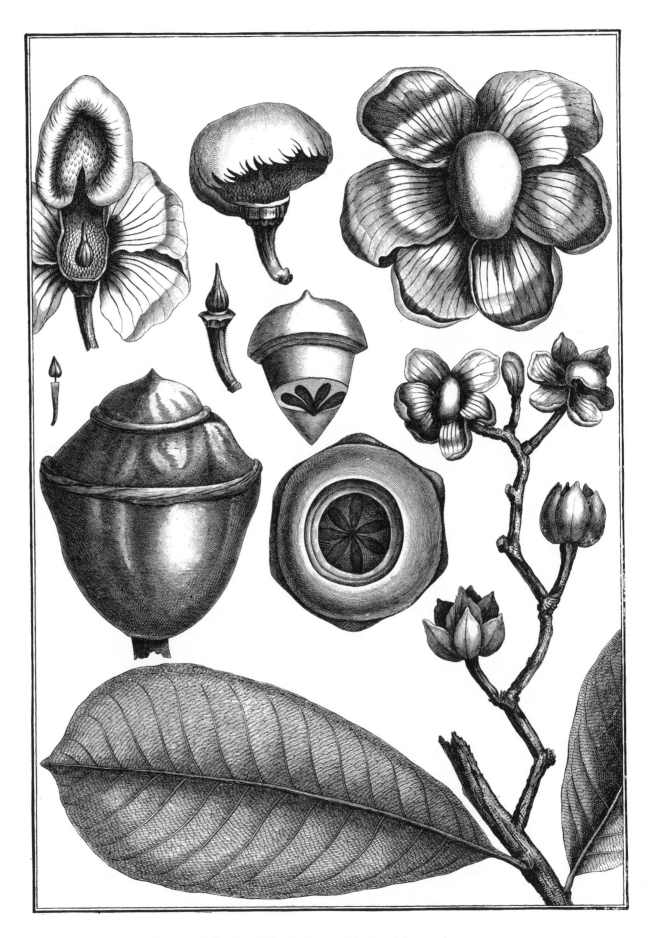

PLATE 128. Studies of the flowers and fruits of the monkeypot tree.

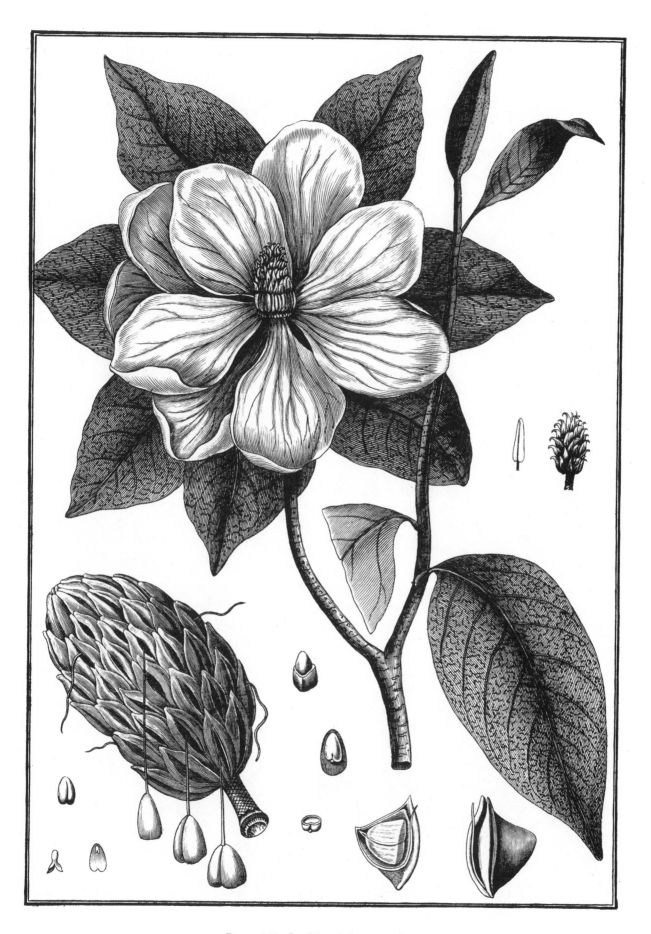

PLATE 129. Studies of the magnolia.

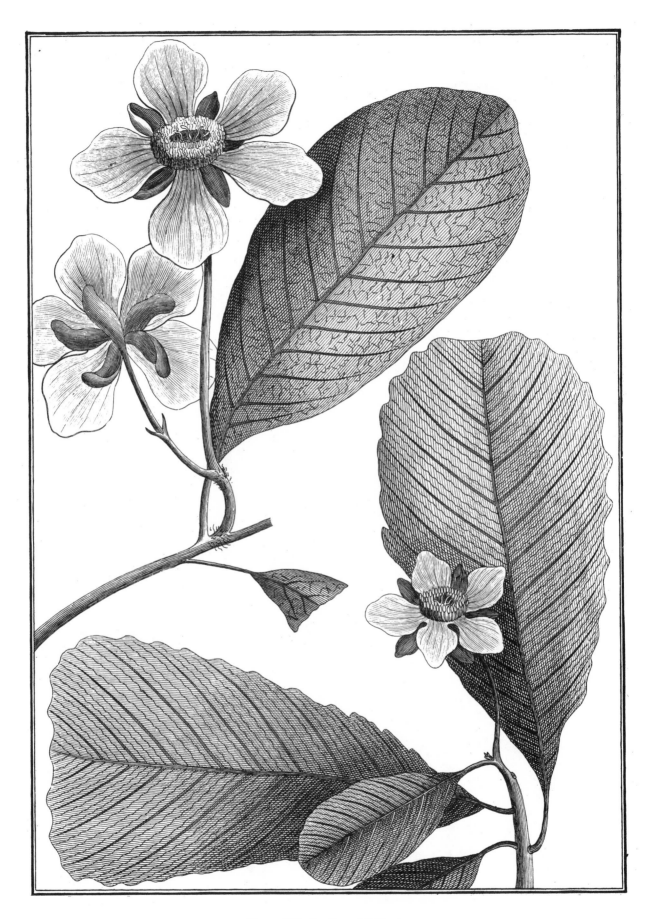

PLATE 130. Studies of Dillenia.

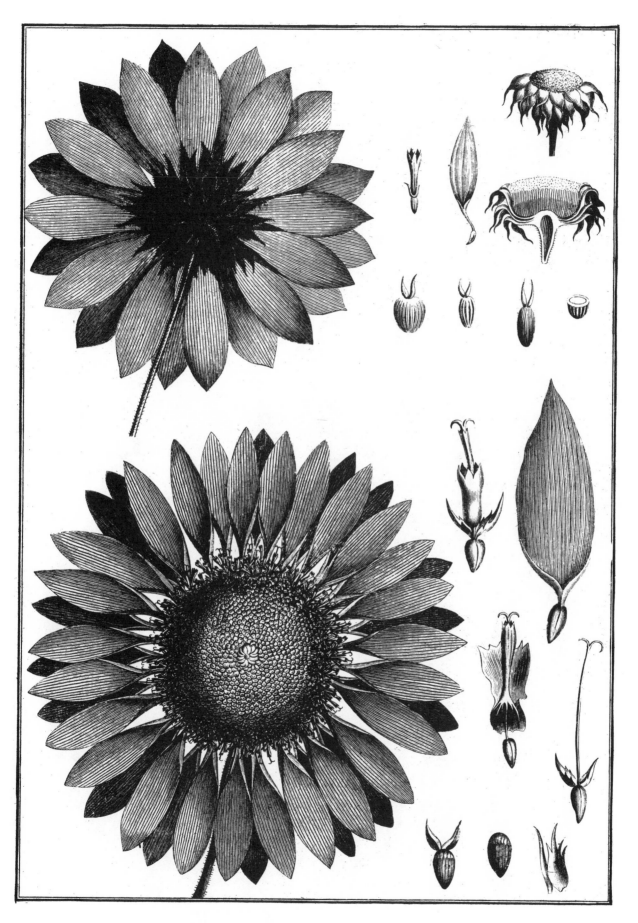

PLATE 131. Studies of two species of sunflower.

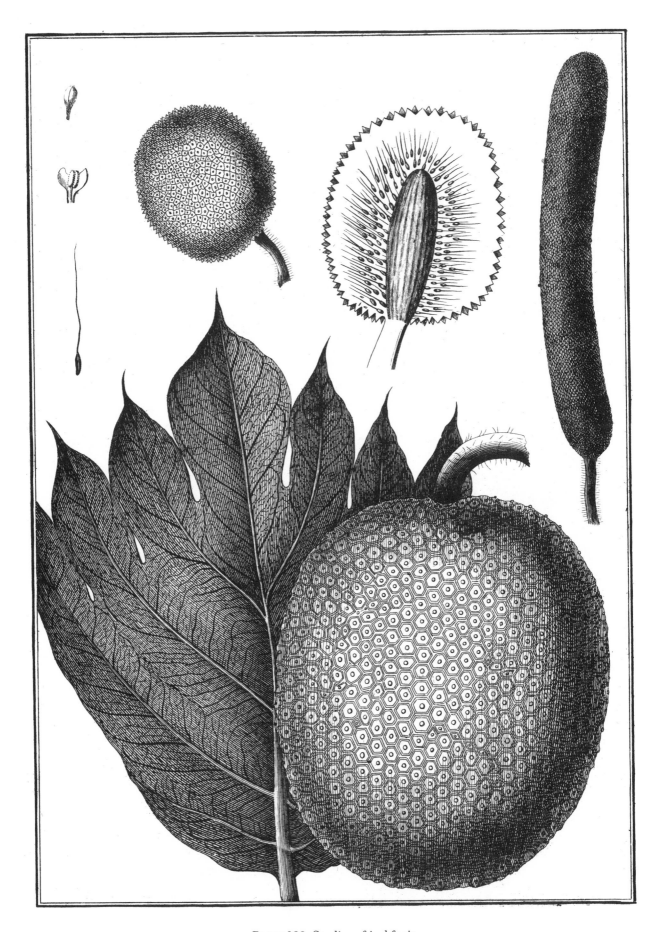

PLATE 132. Studies of jackfruit.

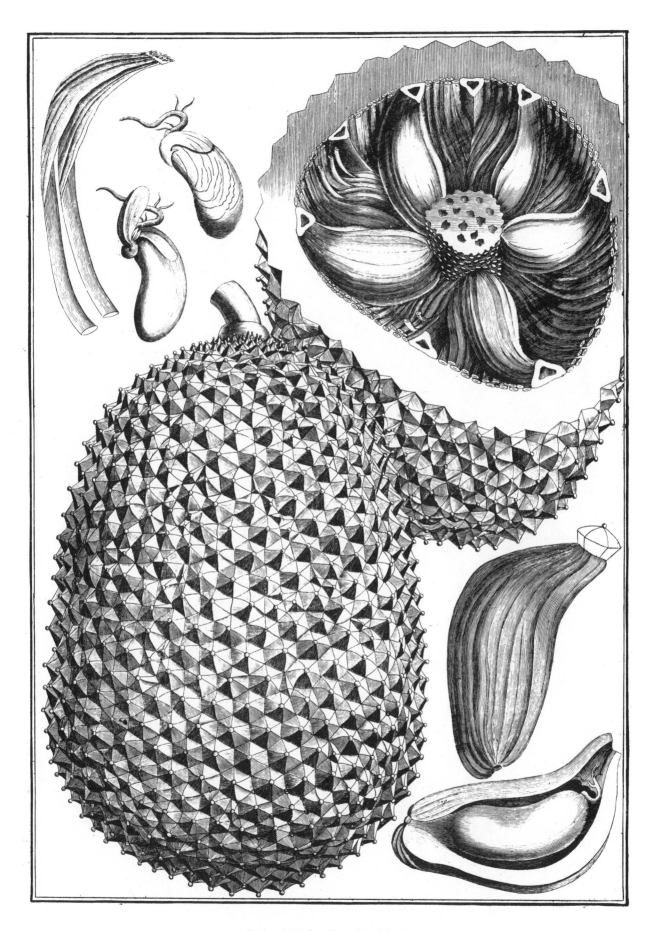

PLATE 133. Studies of jackfruit.

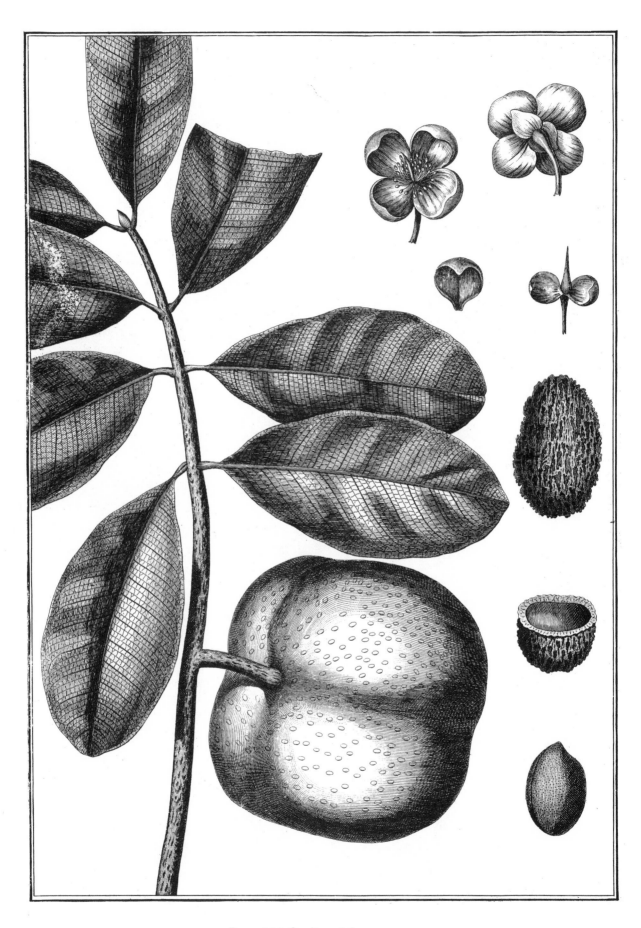

PLATE 134. Studies of the mammee.

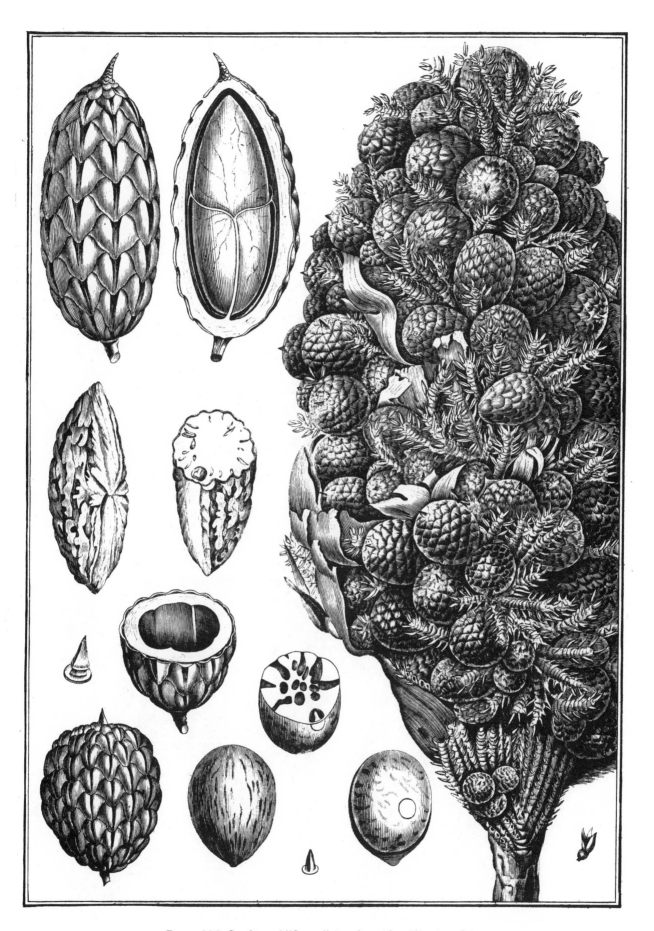

PLATE 135. Studies of "Sagus" (modern identification: ?).

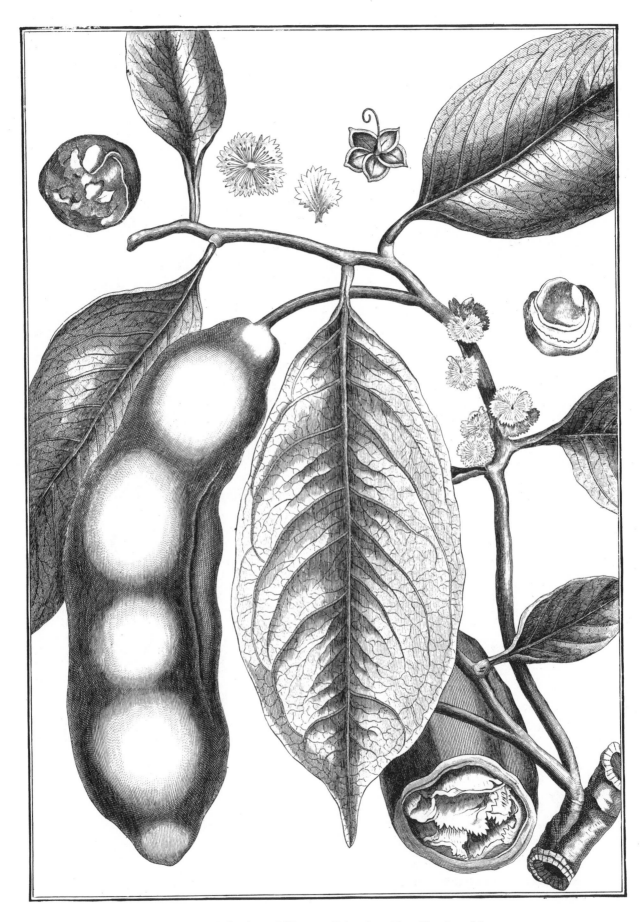

PLATE 136. Studies of "Singana" (modern identification: ?).

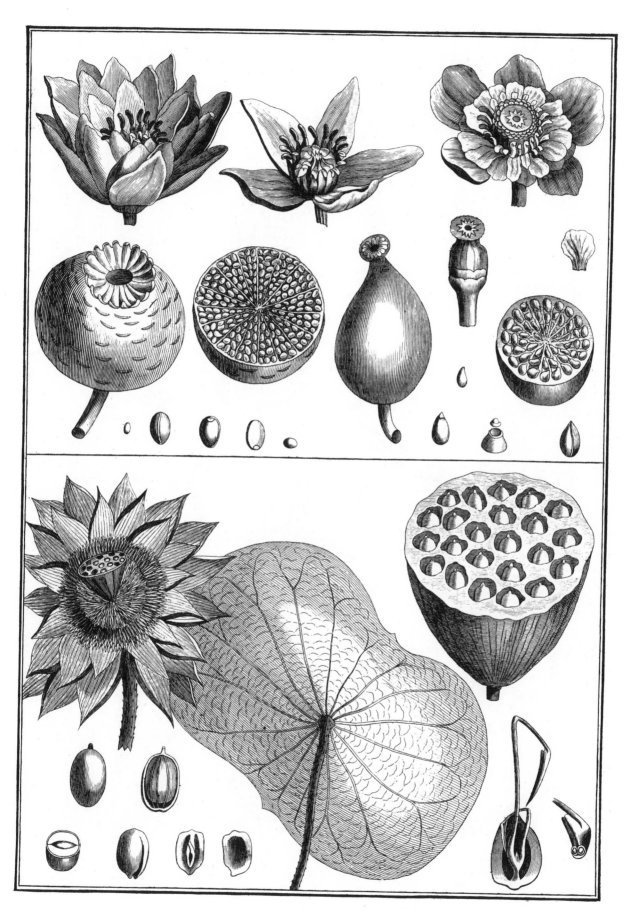

PLATE 137. Various species of water lily and lotus.

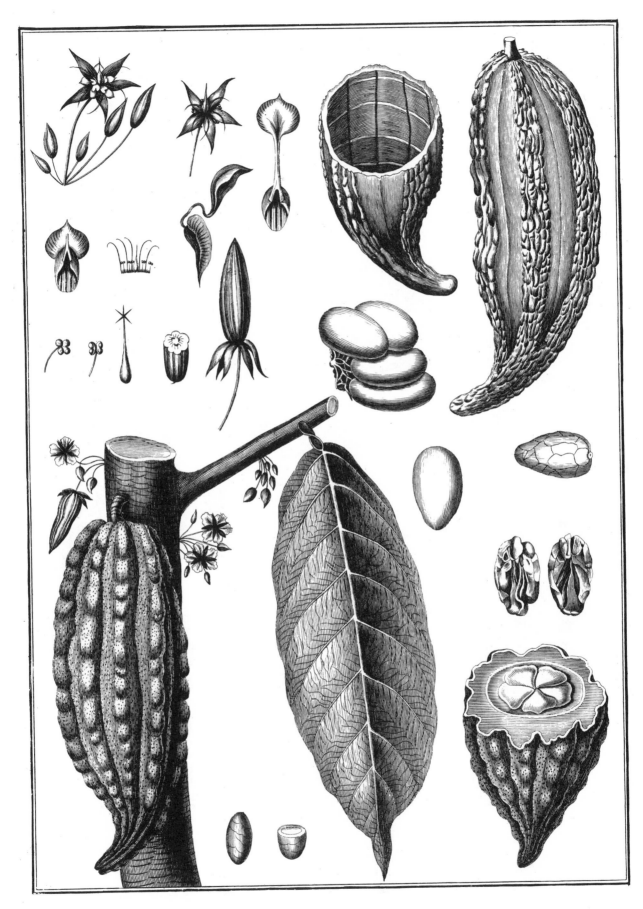

PLATE 138. Studies of cacao flowers and fruits.

INDEX